W9-CZU-926

The Crucifixion
in American Art

The Crucifixion
in American Art

by ROBERT HENKES

McFarland & Company, Inc., Publishers
Jefferson, North Carolina, and London

Library of Congress Cataloguing-in-Publication Data

Henkes, Robert.
The Crucifixion in American art / by Robert Henkes.
p. cm.
Includes bibliographical references and index.

ISBN 0-7864-1499-5 (illustrated case binding : 70# alkaline paper)

1. Jesus Christ — Crucifixion — Art. 2. Art, American. I. Title.

N8053.H44 2003 755'.53'0973 — dc21 2003007866

British Library cataloguing data are available

On the cover: Fred MacNeill, "Connection,"
oil on canvas 18 × 24, 1993 (courtesy of the artist)

Manufactured in the United States of America

McFarland & Company, Inc., Publishers
Box 611, Jefferson, North Carolina 28640
www.mcfarlandpub.com

Contents

Contents

INTRODUCTION

Religious art was considered in such broad terms during the 18th and 19th centuries that it lost its true meaning. The capturing of nature on canvas was motivated by religion. Thus, the newly discovered natural wonders took on a religious connotation. The church of America, reminded of the great religious works of the European Renaissance, never considered the painting of nature to be uniquely American. Even when the church and artist seemed compatible under the name of liturgical art, objections to cementing this relationship arose from the competition with architectural structures and interior design. The liturgical artist was and is now a true example of the religious artist. The religious artist must remain free to paint Christ as he wishes; he cannot be governed by architectural restrictions.

Thus, those artists who painted images of Christ were free to be artists in the truest sense. Many of their works, however, raised objections from church parishioners who preferred less realistic depictions of the Crucifixion. To appease and accommodate the parishioners, the clergy banned a public viewing of the Renaissance masterpieces depicting the Crucifixion. Thousands of such paintings were stored in church basements and museum vaults, never to be viewed by the public.

Undaunted, artists continued to depict the Crucifixion according to inspiration and influence. Painters like Louis Kurz, Benjamin West, and John Valentine Haidt were influenced by the European Renaissance artists and continued that tradition in America during the 18th century.

American painting of the 19th century proved to be more adaptable to the religious fervor of the time and place. Painters like Julian Russell Story, John Singer Sargent, Vassili Verestchagin, Fred Holland and others broke from the Renaissance tradition to begin a religious art revolution.

Although some painters in the first quarter of the 20th century persisted with the styles of the 19th, the arrival of the Great Depression brought about change,

and with World War II the Realist style became the most popular form of expression of the Crucifixion. In the mid-fifties the art world was astonished by the drip method, which was also known as action or gesture painting, of Jackson Pollock. The Abstract Expressionism of Pollock and his peers continued through the remainder of the 20th century, incorporating under its umbrella a number of experimental styles, such as Op, Pop, and Super-realism. These latter styles were short-lived; although the 21st century saw them sustained in a few scattered works, the Abstract Expressionist movement diminished.

Three-dimensional works known as installations have become a major force in this young century. Unpredictable as art is, no one knows what styles and subject matter will dominate the 21st century. If no prominent movement is featured, the 21st century may be one of total freedom leading to a mixture of styles. Free thought may produce works characterized by indifference, opposition or blasphemy. Or a cause may create a new religious revival. That is the beauty of art — it expresses one's personal faith, no matter what that may be or how it is derived.

THE 18TH CENTURY

Although several drawings and watercolors of the crucifix were painted in America during and before the 19th century, they differ considerably from depictions of the Crucifixion. The Crucifixion painting is an expression which is less direct. In other words, a crucifix complements the shrine, bulto or retablo, but does not deal with the crucified Christ and his followers as an individual theme. Crucifixes serving as a subordinate aspect of a shrine or retablo were created by hundreds of colonists and missionaries who remain unknown.

The crucifixes were not conceived as artistic, personal expressions of the artist but more as temporary additions to serve temporary needs. The crucifixes that occupied the Southwest during the 18th century were gradually ignored and eventually disappeared as the nation expanded.

Meanwhile, the philosophy of the 18th century considered the expression of nature as religious art. And so the newly discovered landscape of America became the motivation for a religious art experience.

The few truly religious artists of the 18th century, although influenced by the European Renaissance, took a very personal and intimate approach to the Crucifixion. Aside from Benjamin West, John Valentine Haidt and a few others, the 18th century produced but few truly religious artists who expressed the Crucifixion as a form of personal faith. During the 18th century the landscape remained the foremost means of expression until the early segment of the 19th century.

Other 18th century artists such as Edward Hicks painted religious events of a peaceful nature; they never painted the Crucifixion.

John Valentine Haidt

Several American artists have been influenced by the European Renaissance period. John Valentine Haidt was one of them. He was born in Europe in 1700 and studied there until he came to America in 1754. His painting titled *Lamentation at the Foot of the Cross* was executed between 1755 and 1770. The painting depicts Christ being lowered from the cross shortly after his death.

In the central portion of the canvas and surrounded by the weeping Marys and a fourth figure (possibly Nicodemus) is a circular composition which consumes much of the working surface. The body of Christ is limp and scarred from the scourging. Blood oozes from his disfigured body. Haidt handled the matter of agony and suffering in a traditional manner without sacrificing the emotional reaction of the onlookers. The gravity of the grueling event might force one to genuflect and kneel in profound prayer and contrition.

The five figures are very closely united both in their emotional responses to the event and in the artist's compositional use. Foreground and background are fused as no baseline or skyline is evident and the environment is downcast and mute. The upright segment of the cross seems to divide the left and right areas of the painting.

The side of Christ's distorted body is streaming with blood and his head has fallen helplessly to the left while resting on his left arm. The mourners appear to have difficulty in lowering Christ to a restful position upon the earth's surface. The strength of Haidt's portrayal and the deliberate yet precise areas of suffering he has depicted are in the hands, feet and side of Jesus. The crown of thorns holds a strong symbolic meaning, but it is seldom defined strongly enough in art. The Renaissance painters applied halos to the head of Christ as well as those mourning the event. Eighteenth century artists, including Haidt, did not omit the crown of thorns, but they did not emphasize it either. In contemporary works, on the other hand, it has become a major element of Christ's suffering.

Haidt was influenced by the Renaissance painters of Europe until his death in the year 1780. *The Crucifixion* by John Valentine Haidt was painted between the years 1758 and 1779. It also bears the traits of the Italian Renaissance. One major difference is the several groupings which form individual compositions. The viewer's eye leaps from one grouping to another until all are studied. And the eye reviews all compositions as a single unit. One figure and one grouping leads on to the next until a circular composition is formed. The crucified Christ, although occupying a central location, sustains a remote area in the painting.

A number of human beings grace the foot of the cross, all revealing signs of anguish or exhaustion. A Roman soldier on horseback glares at the behavior of the mourners. Christ is secured to the cross with four nails, which differentiates the painting somewhat from certain Renaissance works. Christ's head is tilted to the right, lowered as if resting on his right shoulder. Facial gestures of those gathered below vary from sadness to greed to anger to revenge. *The Crucifixion* is actually a montage of events which could serve well as a segment of a mural.

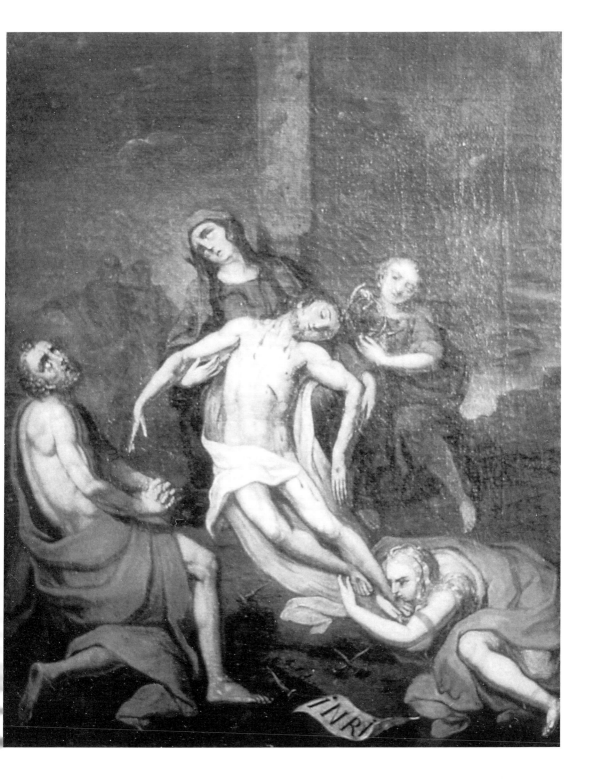

Lamentation at the Foot of the Cross by John Valentine Haidt (between 1755 and 1770). Oil on canvas. 14 × 12 in. The State Museum of Pennsylvania, Pennsylvania Historical and Museum Commission.

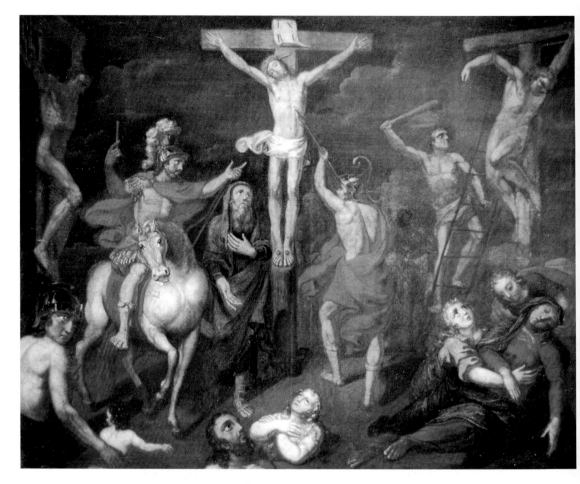

The Crucifixion by John Valentine Haidt (between 1758 and 1779). Oil on canvas. 40½ × 51 in. Moravian Historical Society, Nazareth, Pa.

Activity reigns throughout the painting. No area is empty. Even the seemingly mute sky occupying a third of the working surface is overcast and contributes to an emotional response. It is an unsettling composition, and several viewings of it are essential to a full appreciation of Haidt's portrayal.

The Crucifixion is an American's version of the Italian Renaissance. It was painted by an American, possibly before America became a free nation. Nonetheless, it influenced artists who followed. Paintings by George Bellows during the early 20th century are examples as well as Thomas Eakins and Louis Kurz's of the 19th century. Haidt's painting is a refreshing continuance of the early European works. Although he was born and studied in Europe, his last 25 years were spent in America, where he died and was buried.

Haidt has added action to his portrayal, which differs from many of the Renaissance productions. Even though the subject matter was carefully conceived and positioned and rendered in a motionless appearance, Haidt's depiction is

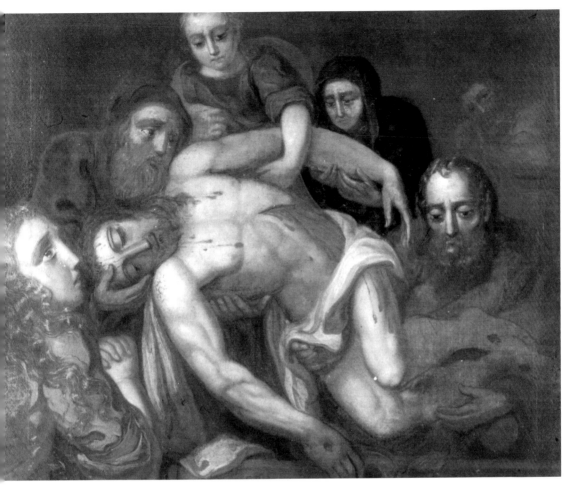

The Lamentation Over Christ's Body by John Valentine Haidt (between 1754 and 1774). Oil on canvas. Moravian Historical Society, Nazareth, Pa.

extremely active, resembling a scene from a dramatic movie. Although the human figures relate to the Crucifixion, each is obsessed with concerns other than the event itself. Each figure has a role to play. So, in a sense, Christ is ignored.

A major difference between Haidt's expression and that of the Renaissance artist is the absence of donors who were included in the painting. Nonetheless, the focus is less on the figure of Christ and more on the audience. The expression is dramatic in the compositional movement of the figures, a movement created by positioning them in appropriate areas so that the viewer eventually views the purpose of the painting.

The Lamentation Over Christ's Body is a compact, agonizing portrayal painted between 1754 and 1774. The muscular body of Christ occupies the central position of the canvas surrounded by several figures which include Mary Magdalene and Mary, the mother of Christ. Christ's body is bent toward the left, thus drawing

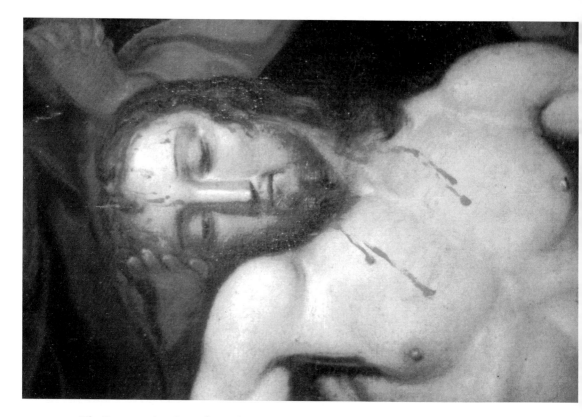

The Lamentation Over the Body of Christ by John Valentine Haidt (detail) (1758). Oil on canvas. Moravian Historical Society, Nazareth, Pa.

attention to the weeping Mary. Five figures form a circular bond surrounding Christ's body.

John Valentine Haidt followed the European Renaissance school except for a few details, notably the pierced side of Christ. The Renaissance painters expressed the piercing on the right side of his body while Haidt repeatedly painted the piercing on the left. Each figurative head reveals facial gestures of sorrow and gazes downward at the figure of Christ. Blood streams down the left side of his body and also from his forehead, from the wounds created by the crown of thorns.

The Lamentation Over Christ's Body is not easily forgotten. One can readily become a part of the painting, placing oneself within the framework of the canvas. This is due partially to the subjective nature of the portrayal. One glance takes in the entire painting. Although one's eyes tend to follow the mourners' facial gestures, the focus always returns to Christ's body.

Because of the total occupation with the event, there is little space left for contemplation. One witnesses the results of a torturous death, and Haidt utilizes his knowledge of anatomy to full advantage. Christ's head is gently held in place by one of Christ's followers, but it is Christ's massive body that is featured.

Segments of his body are twisted to indicate the severe agony; but Haidt also used Jesus' racked form as the core of his composition. The surrounding figures add to the tension and the reaction of the viewer without displaying an obvious and deliberate positioning. Each has a role to play and each does it well.

A detail of a painting is a section which reveals a special area of the work. It is an intimate view of a singular aspect. A detail is in fact a total and complete composition subtracted from the original painting. A detail reveals an aspect which may appear secondary within the complete painting, but with a special treatment, affords the viewer a glance of an intimate nature. A detail is seldom concerned with a compositional background or the effect that the background has upon the subject matter since the background is usually the space remaining aside from the detail itself.

In the case of the 1758 painting *The Lamentation Over the Body of Christ* (not to be confused with the similarly named *The Lamentation Over Christ's Body*), Haidt had selected the face of Christ as the focal point and dominating feature. The detail brings forth the facial gestures which generally go unnoticed while viewing the original work. There is the positioning of blood spots, the closed mouth, the seemingly closed eyes which glance slightly downward making the distribution of blood streaks more easily discovered and recognizable. Viewing the detail, one realizes that Haidt focused on the muscular makeup of Christ's physical structure, pinpointing several areas which force an emotional reaction from the viewer. The entire composition reveals the results of intense agony stemming from a single source. This detail suggests to the viewer the intimate makeup of the entire painting.

The facial features are clearly articulated, the nose surprisingly reflecting a Greek influence. The positioning of blood spots was carefully calculated so that the distribution did not become obvious. The space surrounding the blood spots is ample, creating a significant service to the whole. The purpose of a detail is to finely depict the features which reveal the utmost care given to all aspects of the whole. Thus, if the detail is masterful, the viewer can be assured of a masterful painting. Because of his Renaissance influence, Haidt has succeeded in ushering into 18th century American art the significant aspect of the Crucifixion.

Benjamin West

The drawing *The Crucifixion* by Benjamin West has all the earmarks of a European Renaissance influence. Although the work appears to be more of a sketch than a drawing, it is the latter, and if continued in the same manner, it would definitely be considered a drawing with a distinct European flavor. A sketch is an idea or a series of ideas, a tryout, if you will, of piecing together elements to make a whole. A drawing is already a whole and considered a total expression.

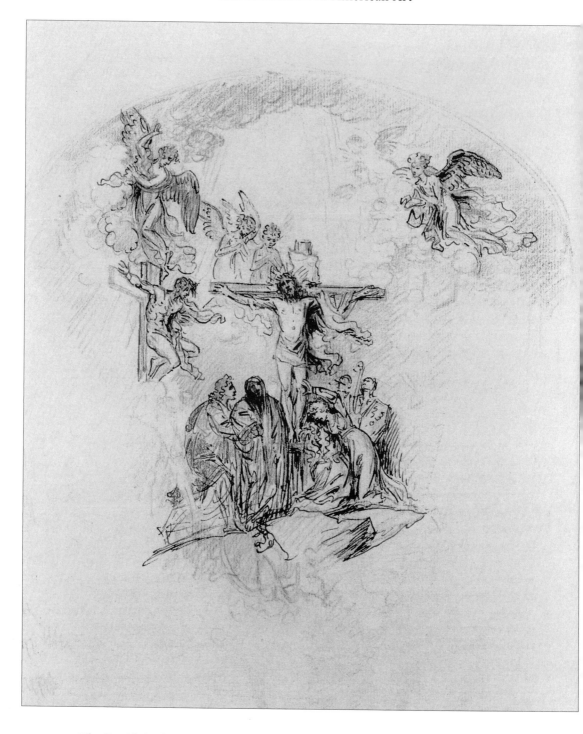

The Crucifixion by Benjamin West (1796 or 1797). Pen and brown and black ink with blue, black, and red chalk on laid paper. 11½ × 9⅜ in. National Gallery of Art, Washington, D.C.; Julius S. Held Collection; Avalon Furar.

West has allowed space within the drawing to allow for the insertion of elements or figures to balance the work formally, which is not unlike the manner used by the European Renaissance painters. Christ on the cross is centrally located with the usual surrounding mourners. Angels appear in the upper right and left corners of the canvas, while two others of equal size move in from behind the cross. A lone crucified figure highlights the center left while an equal area of space is left open for a similar figure to be placed in the center right. A group of mourners gather below the cross.

Even though his work is perhaps in some respects a sketch, West has already worked in details within the central figure, thus repeating a European Renaissance trait. What appears is a mental image of the completed expression, and it becomes a matter of time before the drawing would be complete with negative and positive space working together. The inclusion of appropriate elements would have determined the direction West would have taken. Nonetheless, the drawing is a pleasing masterpiece; one wonders what sort of painting West might have created with this drawing as the basis. The artist's delicate touch is exacting and details flourish regardless of the lack of visual perspective.

Unidentified Artist

The complex composition of *The Crucifixion* is not unlike that of the European Renaissance period. The entire painting by an unknown artist is consumed with various events of the commonplace while the crucified Christ holds a central position on the canvas. The viewer is treated to a search of discovery as figures are positioned in overlapping order. The figure nearest to Christ is Mary weeping. A second and third flank the crucified Christ as others in the audience appear indifferent to the scene or preoccupied. The careful and well conceived placement of all images results in their being posed to overlapping perfection. The anatomical structure of the crucified human images is distorted, but apparently not for the purpose of revealing agony and pain. In this sense, one may consider *The Crucifixion* somewhat primitive, because of the lack of knowledge of human anatomy.

There is no sign of suffering, which makes the painting more historical than religious. There is a strong visual perspective. Figures nearest the viewer and those contained within the middle plane are similar in size, but those in the background are extremely diminutive. This size difference results in a sudden and dramatic split between the background and middle ground. The arrangement suggests an overflow crowd of spectators.

The three crucified figures are traditionally positioned. There is a quiet atmosphere, a non-violent appearance and a lack of emotional movement as if the occupants are posed for a group photograph. The environmental background

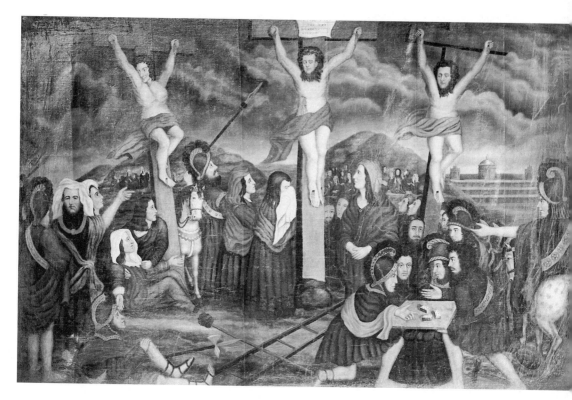

The Crucifixion by unidentified artist (date unknown). Oil on bed ticking. 8' 6" × 13'. Fenimore Art Museum, Cooperstown, N.Y.

of sky is dark with roiling clouds, seemingly preparing for the final hour. The beauty of *The Crucifixion* is not any emotional response it might engender, but in the complexity of the arrangement of its various compositions. Although the drawing appears primitive, the arrangement or composition is much like that of the early Renaissance period.

John Trumbull

John Trumbull's painting titled *Christ Under the Cross (or Our Savior Bearing the Cross and Sinking Under Its Weight)* is directly influenced by the Renaissance painter Peter Paul Rubens. Other American painters of the 18th and 19th centuries were influenced by earlier European artists such as Tintoretto and Raphael.

Opposite: Christ Under the Cross (or Our Savior Bearing the Cross and Sinking Under Its Weight) by John Trumbull (1793). Oil on wood. 24 × 17¹³⁄₁₆ in. Yale University Art Gallery, Trumbull Collection.

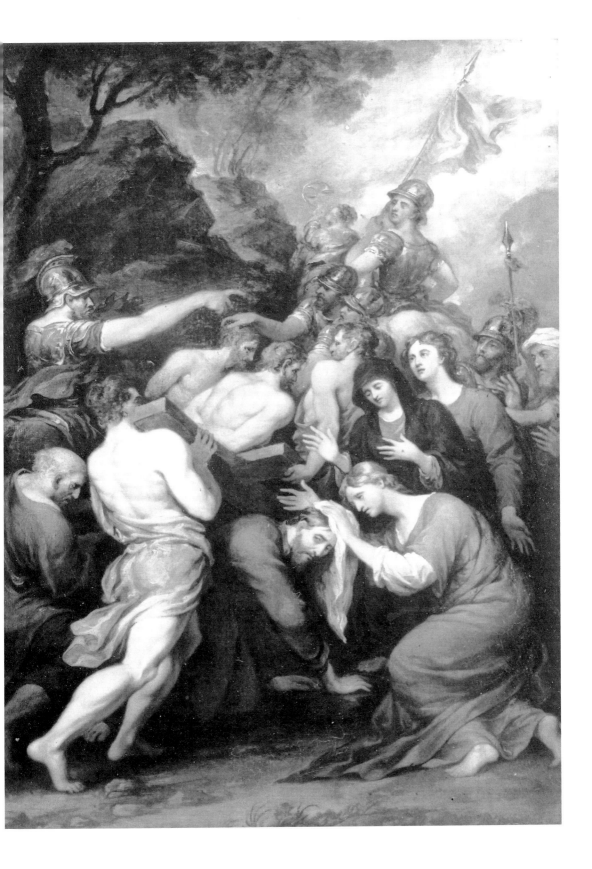

Trumbull's painting, dated 1793, depicts an event leading up to the Crucifixion and reveals Christ on his knees bowing under the heavy weight of the cross. It is composed of numerous human figures with the focus on the intimate composition of Mary wiping the brow of Christ. All facial gestures of the mourners reflect sorrow as they gaze intently upon the agonizing Christ. The intricate arrangement of figures reveals both timidity and strength. The brute force of the soldiers is seemingly assisting Christ on his death journey and the quiet consoling gestures of the mourners are supporting him in his agony.

Christ Under the Cross is a strange composition. The right side of the painting reveals front views of the suffering spectators while the left side exhibits the rear view of the offenders. Because of the complex arrangement of human forms, it is both subjective and objective. The numerous overlapping figures form a single aspect of a complex work, forcing the viewer to acknowledge the numerous human beings before attending to the crucified Christ whose head is partially hidden from view. All action is positioned in the foreground, except for a stormy area of the sky in the upper section of the painting. There is a sense of urgency as the crowd aids Christ towards his death. It is only partially compassionate, which reflects the intense opposing forms of sorrow and indifference. The inclusion of the Roman soldiers spearheading the event becomes a significant aspect of the composition. There is a strange opposition of tenderness and callousness.

Trumbull's *Christ Under the Cross* reflects the reliance upon the European Renaissance movement regarding the expression of religious and spiritual events.

THE 19TH CENTURY

The 19th century changed little from the 18th except that the production output expanded. Artists continued to reveal a European sensibility, such as the influences evident in the work of Julian Story. His portrayal *Deposition* approaches, in near detail, a Renaissance painting, and strongly resembles the anatomical portrayals of a Titian or Rubens. Others like T.W. Freeman retained a compositional adherence to the European Renaissance but combined realism with bits of primitivism. As the century progressed, however, fewer artists relied upon the influence from abroad.

Louis Kurz and Vassili Verestchagin of the latter part of the 19th century seemed compelled to relate to the Renaissance, judging from the way they depicted the figures surrounding the cross. Two unidentified artists positioned Christ as the central figure in a somewhat more personal approach. The productions of the 1880s were modifications of the European arrangement of the numerous figures which are usually evident in Renaissance works.

Augustus Vincent Tack became one of the first to break the dependence upon the European influence. In his painting Christ alone occupied the central position of the painting, balanced formally by an orb — a sun? a moon? — on each side of the cross. In addition, he included single figures to balance the extreme sides of the canvas.

Fred Holland became an Ultra-realist. He had himself physically placed upon a cross and photographed — a highly personal and unusual approach indeed. He even grew a beard and fasted for 40 days to display a physical resemblance to the crucified Christ.

As the 19th century neared an end, the portrayals changed drastically as artists broadened the scope of the Crucifixion into a social commentary. The crucified Christ became a symbol — not a figure on the cross but a symbol of society's sins.

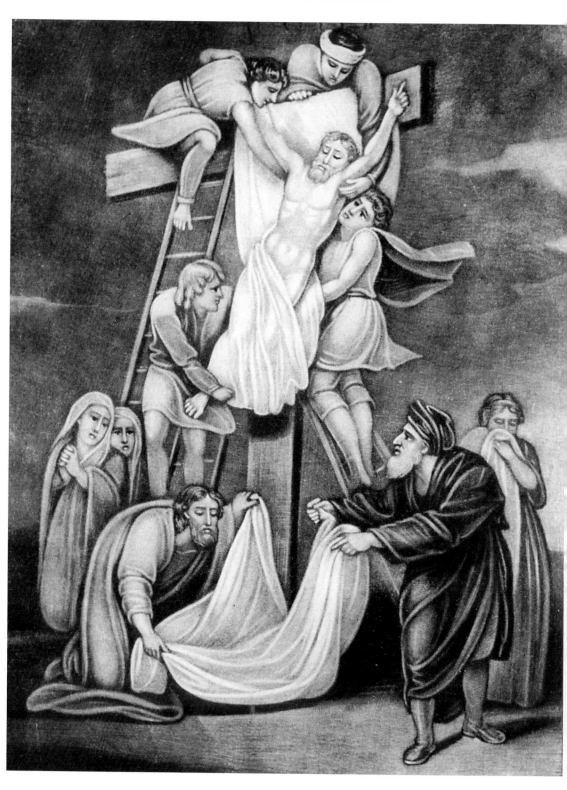

T. W. Freeman

The 19th century painting by T.W. Freeman titled *The Descent from the Cross* (1812) is all consuming. Each of the nine figures assisting Christ from the cross is delicately detailed, and this is not unlike the influence of the Italian Renaissance. The composition becomes an oval display of human beings each tending to the sacred duty of relieving the deceased Christ from the agonizing experience of the Crucifixion. A delicate cloth or blanket shelters Christ from further scars as two figures gently lower the body to figures on each side of the cross. At the very foot of the cross two male figures prepare the cloth in which Christ is to be wrapped before entombment.

A ladder is propped against the cross on each side as Christ is carefully lowered to the ground. There are no signs of torture on Christ's body, nor is a crown of thorns evident upon his head. His skin is lightly colored as if blood has been drained from his body. Freeman's knowledge of anatomy is evident in the physical makeup of the mourners and those humans assisting in the descent. Folds and creases in the attire of each figure reveal contours which reflect the structure of the human form. Although a Renaissance influence is in evidence, a major omission is the halo which during the 18th century was replaced by the crown of thorns. But strangely enough, Freeman has omitted the crown also. All facial gestures of the nine figures in addition to that of Christ are individually personalized. Each figure is preoccupied with a single task, that of lowering the body of Christ from the cross. The compatibility of each human to all the others creates a common bond to form a oneness—nine single occupants blending into a single aspect of a human's life. The artist has devoted the entire composition to a subjective expression. Tightly positioned although individually treated, each figure is objective but together they form a personal portrayal. The background environment remains still and the few darkened clouds tend to move slowly behind the crucified Christ. Freeman's *The Descent from the Cross* is an American attempt to use aspects of the European Renaissance and broaden the experience in an American fashion.

Vassili Verestchagin

Vassili Verestchagin has purposely positioned Christ and the two thieves at the very edge of the canvas. The viewer is immediately drawn to the foreground of Roman soldiers who direct the viewer's eyes to the far right of the painting. Placing the major figure of Christ in the most remote location of the canvas and

Opposite: The Descent from the Cross. Dedicated to the Christians of All Denominations by T. W. Freeman (September 1812). The Library Company of Philadelphia.

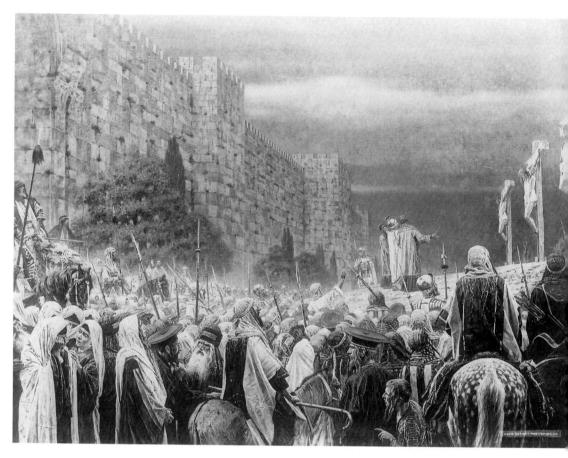

A Crucifixion in the Time of the Romans by Vassili Verestchagin (1876). Oil on canvas. Library of Congress, Washington, D.C.

allowing the detailed studies of the Roman soldiers in the foreground, who incidentally occupy half of the painted surface, demands immediate attention. Few spectators are mourners, although a few peasants are scattered amid the large audience.

As the viewer visually reaches the event of the Crucifixion, he is faced with the three crucified humans bleeding from the intense torture administered by the Roman soldiers. The painting titled *A Crucifixion in the Time of the Romans* exhibits a complex overlapping of humanity. Their gaze toward the figure of the crucified Christ brings into play the event which is remotely expressed, but for this very reason what appears remote becomes all-important. Vassili Verestchagin has used reverse psychology. He has focused on the vast crowd as spectators whose eyes are directed toward the remote edge of the painting. Although one is tempted to study their facial gestures and body movements, eventually Christ becomes the sole purpose of the painting.

The composition is divided into three sections, each serving a different pur-

pose but all contributing to the whole. The foreground of spectators consumes about one-third of the entire painting; the huge walls of Jerusalem occupy the entire left side of the painting, leaving a portion of the sky to fulfill the third portion of the canvas. The three crucified humans are based in the foreground but extend into the sky area. Even though the sky is darkly overcast, the highlights reflected on the faces of the crowd would indicate the fatal hour has not yet arrived.

The distance between the Roman soldiers on horseback located at the very left edge of the painting and the crucified Christ at the very right edge creates a potentially tense moment. If that distance lessened, the intensity would increase.

Verestchagin's *A Crucifixion in the Time of the Romans* does indeed exemplify the time of the Romans. Today, however, the expression of the Crucifixion has become more personal with far fewer spectators. The visual dialogue is between the subject matter (Christ) and the artist. Verestchagin's painting is an historical event as well as a religious event.

Unidentified Artist #1

The circa 1825 image titled *Crucifixion—New Mexico* (not pictured) is known as a retablo, which was a common type of production during the 18th and 19th centuries. (Retablos were established by unidentified artists whose message was to spread the gospel of Christianity. They were constructed for outdoor shrines and spotted throughout the countryside.) The figure of Christ occupies the central position and is flanked by two diminutive figures, Mary and Joseph. All figures are crudely expressed, especially the figure of Christ, whose body is spotted with red pigment symbolizing the blood flowing from his body. His head appears abnormal and crowned with thorns.

It is strange and perhaps unaccountable that Christ's left hand is spotless, clean and free of blood stains. Because the figure of Christ overpowers the figures of the two mourners, one tends to focus on the Christ figure and ignore those mourners below the cross. Even then, deeply devout facial expressions reveal the sorrow each figure endures. Mary does wear a halo about her head while Joseph's head remains bare. This rather insignificant revelation is both symbolic and effective in distinguishing the importance of each human form.

Crucifixion—New Mexico is a simple and crude depiction of a theme literally unknown and seldom expressed, but which gradually gained recognition during the 18th century. Retablos were created and established by self-taught folk artists, which made them more provocative than the works of many of the so-called trained academy artists.

Unidentified Artist #2

Dated circa 1840, *The Crucifixion* by an unknown artist leans heavily in composition toward that of the European Renaissance era. In this simply designed painting the crucified Christ is at the center and is surrounded by the three weeping Marys, each of whom is painted in a saddened pose. The circular movement of the four figures is not unlike that of the Renaissance times. The figures are barefoot and draped in long gowns. The central figure is probably the mother of Christ; she kisses the feet of her beloved son.

The figure of Christ not only sustains the halo, an obvious symbol of the Renaissance, but also bears the crown of thorns. *The Crucifixion* is a quiet expression composed in an intimate and personal manner. The background is darkened by the hour of death. Light breaks through the black clouds as if to reveal the body of Christ.

The Crucifixion takes place on the outskirts of the city. Thus, the foreground is made up of rocky slopes of earth, resembling to a lesser degree the rocky terrain of Golgotha. There are signs of resignation, facial features reflecting anguish and sorrow as if the crucified Christ had already died. The artist has attended to four figures, granting each an individual facial countenance. Each figure sustains a characteristic display of devotion. In spite of their being four individuals, each is a link to a oneness, a combination of spirit and profound devotion. *The Crucifixion* has a formal, balanced look which grants each figure an equal amount of attention. However, because of the positioning of the crucified Christ, the focal point is centrally located. Without question, Christ was positioned specifically for that purpose.

William Merritt Chase

Crucifixion by William Merritt Chase is a classical and traditional rendition of the crucifixion of Christ. Dated 1869, it is quite similar to those of Ralph Pearson and Thomas Eakins. This simple composition leaves no doubt as to the central interest. To witness Christ's Crucifixion is to face death. The stillness of the victim, the lack of physical distortion and the lack of bloodshed make Chase's expression almost a quiet event. The cross has become part of the darkness as Christ appears to be floating in air. No halo, no crown of thorns and no signs of agony or humiliation. Hands are clenched, but nails are not evident. Likewise, the feet reveal no signs of blood.

Opposite: The Crucifixion by unidentified artist #2 (c. 1840). Oil on canvas. Collection of the Flint Institute of Arts, Gift of Edgar William and Bernice Chrysler Garbisch, 1981.5.

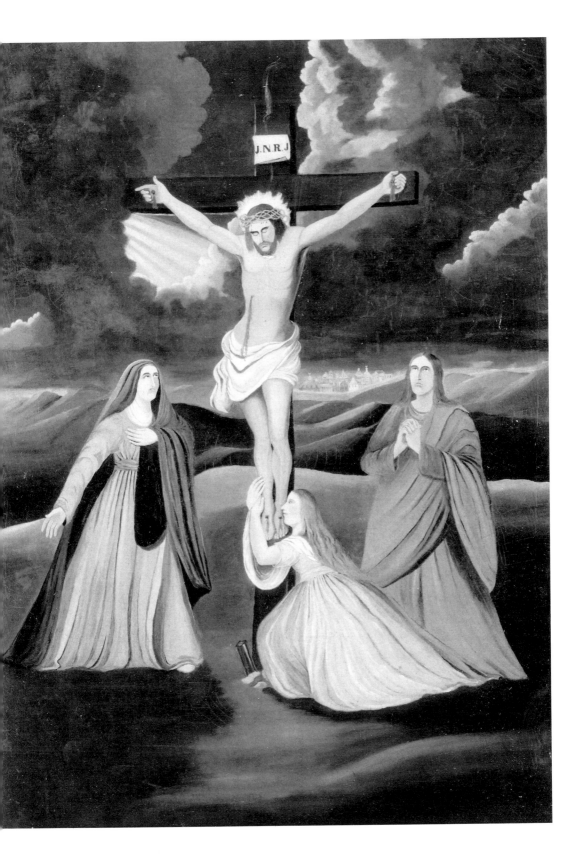

Crucifixion does reflect a bit of the optical illusion approach. The figure positioned on a total working surface of black enamel offers the viewer a full vision of the crucified Christ. Shadows and highlights emphasize those areas intended for total consumption. Christ stands as if in a trance as the use of black tends to shrink the bodily features and lessen the power of Christ.

Christ is pictured as if resigned to death. There is no excitement. It is personal. His image of death he prefers not to share with others, whether mourners or mere spectators. Perhaps the most significant feature is the starkness of Christ's body against an equally stark background, notwithstanding which the work still comes off as a complete composition. It would seem that the entire background being black would tend to swallow the rather quiet and meek appearance of the victim, yet it does not.

Chase's version is a direct hit with no objective images interfering, with the only subject matter being the crucified Christ. It is by no means influenced by the European Renaissance. Instead, as with Eakins and Pearson, Chase's version is personal — a form of communication between Christ and the artist.

Thomas Eakins

A quiet, traditional Crucifixion is witnessed in Thomas Eakins' portrayal of this universal theme. A bit of contradiction resides in the physical being of Christ. The hands of the crucified, clawing in anguish as if the pain of suffering is neverending, are reminiscent of Grünewald's famous altarpiece. Yet, the position of the feet of the Savior suggests resignation to the effects of the Crucifixion and acceptance of the destiny of Resurrection.

Both of Christ's feet are resting on a platform. Two nails have been used to secure the feet in place. The background is mute in order to accentuate the crucified Christ. The lower foreground is a mass of rocks representing the desolate area that marks the scene of the event. The hands are stretched and twisted in agony as if reaching out to the viewer. Even though Eakins' painting reveals no sign of blood except for that which oozes from Christ's feet, the taut hands reflect extreme pain.

Christ's head is painted in shadows, and bent downward as if death had already occurred. The crown of thorns piercing his brow is echoed in shadow on the upper left arm. This torturous image is web-like instead of the crushing sharp angular shapes that appear in works by other American artists.

Eakins' *The Crucifixion* is a quiet scene, an event which is no longer, an event which suggests the oncoming of the Resurrection. The paramount feature seems to be the clawlike hands which evidence the only pain. It seems a final gesture before death occurs.

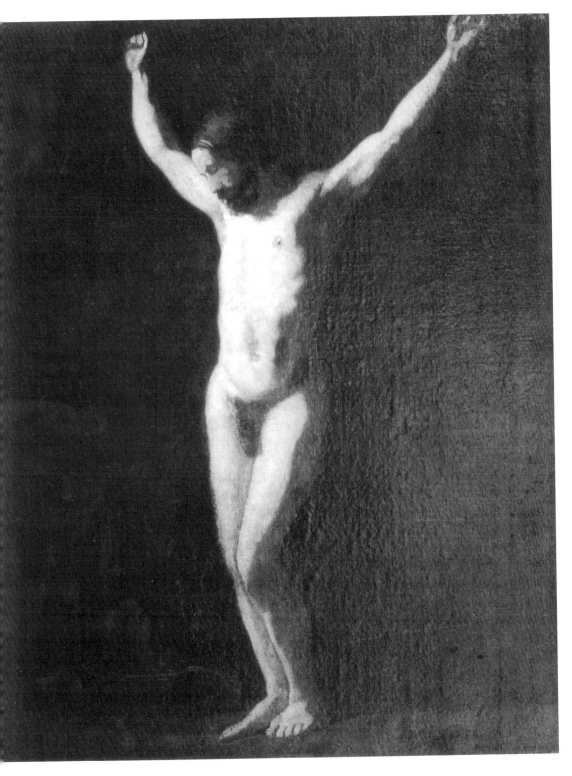

Crucifixion by William Merritt Chase (1869). Oil on canvas. Smithsonian American Art Museum, Transfer from S.I., Cooper-Hewitt Museum of Decorative Art and Design.

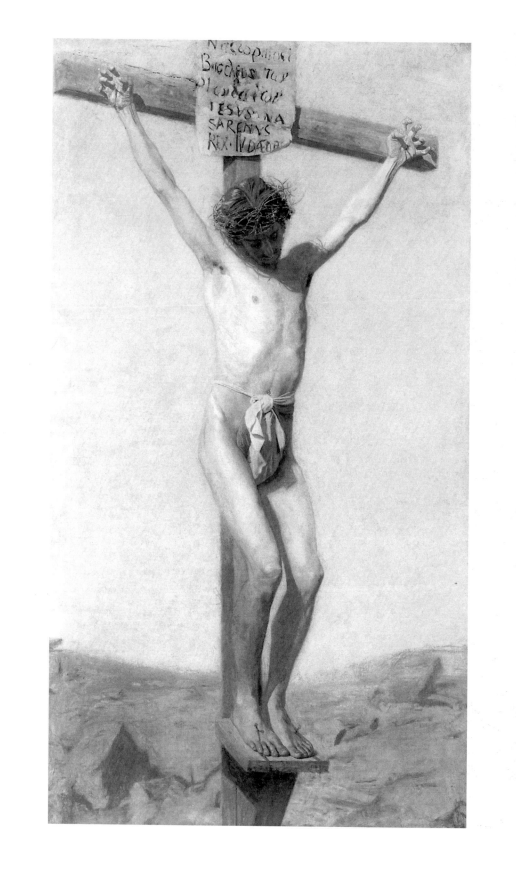

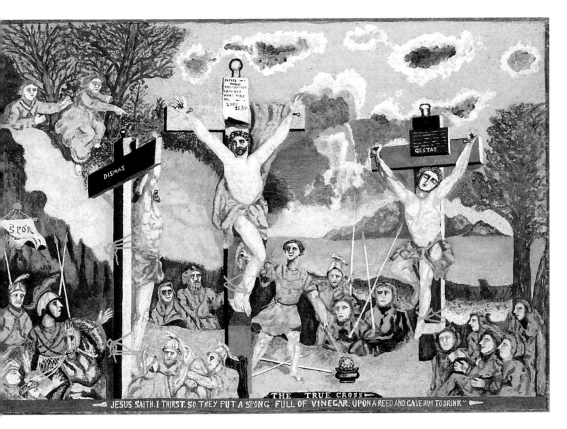

The True Cross by unidentified artist #3 (c. 1880). Oil on canvas. 22½ × 32½ in. Colonial Williamsburg Foundation; Abby Aldrich Rockefeller Folk Art Museum, Williamsburg, Va.

Unidentified Artist #3

Primitive painting was once considered to have reigned only during the 18th century, but the truth is that the style has no time limits. It was much in evidence even in the 20th century. Furthermore, primitive painting is no longer considered a self-taught activity. There are those who purposely chose the simplicity and directness of primitive art, having beforehand dealt with several schools of thought. In between the primitive and realistic stages is *The True Cross*, an 1880 painting by an unidentified artist, which shows evidence of self-taught traits which seem to disappear gradually as realism creeps in.

In *The True Cross* the feet of Christ are tied to the cross as are those of the two thieves. Spikes pierce the wrists of all three figures, and all wear identical loin cloths. Roman soldiers occupy the lower left corner of the canvas. Strangely, there appears to be no bloodshed. The painting reveals several compositions

Opposite: The Crucifixion by Thomas Eakins (1880). Oil on canvas. 96 × 54 in. Philadelphia Museum of Art: Gift of Mrs. Thomas Eakins and Miss Mary Adeline Williams.

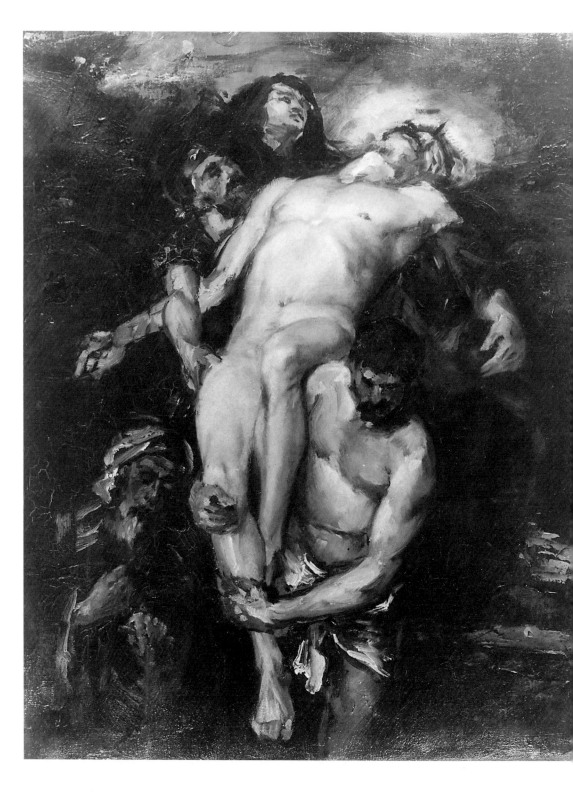

The Deposition of Christ by Julian Russell Story (1881). Oil on canvas. 19⅝ × 14¾ in.
Williams College Museum of Art: Gift of Mrs. John W. Field in memory of her husband.

within the whole, each of which could be enlarged into a total painting. The primitively handled clouds occupy much of the sky; semi-primitive trees adorn each side of the painting. The body of Christ is distorted purposely or perhaps by the nature of the primitive approach.

The Crucifixion site is not the rocky foreground evident in most paintings of this theme. A gully holds five enemies, three of whom hold spears. It is difficult to define a form of composition since the vertical, circular and horizontal planes are used.

Each crucified figure is a focal point with an accompanying audience, and because the focal points are vertical and the surrounding mourners are arranged horizontally, a complete composition results. There are images which may be defined as surreal as well as primitive. In spite of the horrible event, the artist has presented his display to good account, showing a personal approach to an agonizing theme.

There seems to exist an element of the European Renaissance in the painting, at least in the compositional sense, even though the artist has freed himself from any dogmatic criteria. It is difficult to classify a painting in which two or more styles prevail. Such a work occurs when the artist is unaware of a change until the painting is well under way. *The True Cross* appears to be midway between primitivism and realism, which frequently results in the surreal. The question is whether or not the change is intentional; once such a determination is made, the date of the painting can be fairly accurately gauged.

It is always intriguing to witness a change of style within the process of a painting. Once the painting is complete, understanding the work becomes a challenge. Frequently, several misinterpretations occur while at other times a complete failure to accept the work happens because of the conflict between two or more styles.

In a sense *The True Cross* grants the viewer a dual form of appreciation because of the mixture of styles. Furthermore, the change of style may not even exist in the minds of some viewers. At any rate, *The True Cross* represents a personal expression in a compassionate manner. It is strange that the image of such persecution should be enjoyed not so much for its message as the pleasantries of color and composition. Again, personal interpretations flourish even though the artist would appreciate an acceptance of the message.

The True Cross is an example of an unusual American approach to the Crucifixion theme.

Julian Russell Story

Julian Russell Story was born in 1857. In his painting titled *The Deposition of Christ*, Story clung to the late Renaissance school of painting. In spite of Christ's death, he painted his body as vibrant and strong. The work closely resembles a

Tintoretto or Rubens in taking full advantage of anatomical studies. Christ is being lowered carefully to the ground as the women caress his feet and compassionately handle his body.

Story's painting reveals a strong sense of distortion in the foreshortening of Christ's body. Christ's body appears relaxed but a burden to the weeping women. Story has used the entire canvas in portraying the event which is forwarded on the picture plane, thus exhibiting details which at a distance would not be seen. Christ and the occupants at the site allow the viewer to experience an intimate relationship with them.

Even though this image is not of the Crucifixion, the death is so close to the action itself that the painting warranted inclusion in this book. The background is limited because of the need to promote the body of Christ. The diagonal slant of the body differs considerably from the depictions of other artists and is typical of the power exhibited by such painters as Romano, Rattner and Corbino in the middle of the 20th century.

Story was careful to focus on the upper torso of Christ which allowed the viewer to follow visually in either direction. Christ's face is partially hidden because of the position of his body. The entire figure, in addition to the surrounding mourners, controls the center of the canvas in a vertical fashion.

The Deposition of Christ, an 1881 production, is a potentially explosive image and is contained within the framework of the canvas. There is little room for adverse interruptions because of the area occupied by the event itself. Thus, the background is whatever space remains. Story has created a masterpiece by withholding the end of the event. Although Christ has died, the painting continues to live because of its vitality. While artists of the 19th century continued to paint nature, Story preferred to sustain the elegance of the late Renaissance.

Unidentified Artist #4

The Crucifixion by an unknown late 19th century American painter identified with the late Italian Renaissance is a classical painting with the crucified Christ as the central figure forming a perfectly shaped diamond composition. Christ is balanced by the three weeping Marys to the left of the cross and a Roman soldier to the right. Blood is seen gushing from Christ's body. Feet are overlapped and pierced with a single spike. The halo is prominent as it surrounds Christ's head and that of Mary, the Mother of God. Hands of two of the weeping women are folded in a gesture of mercy. The third woman hides her face in disbelief. The head of Christ is lowered to the right, suggesting that he has pleased his Father. The Roman soldier does not gaze at the suffering victim, but instead looks away from what he has done.

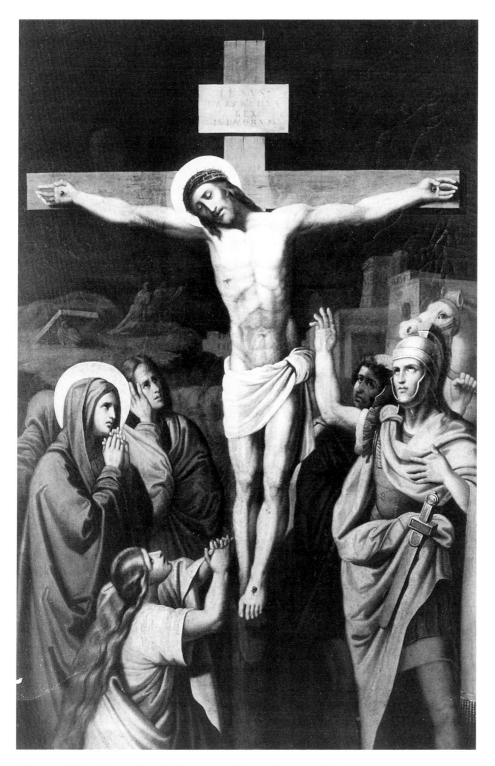

The Crucifixion by unidentified artist #4 (late 19th century). Oil on canvas. From series *Stations of the Cross.* The State Museum of Pennsylvania, Pennsylvania Historical and Museum Commission.

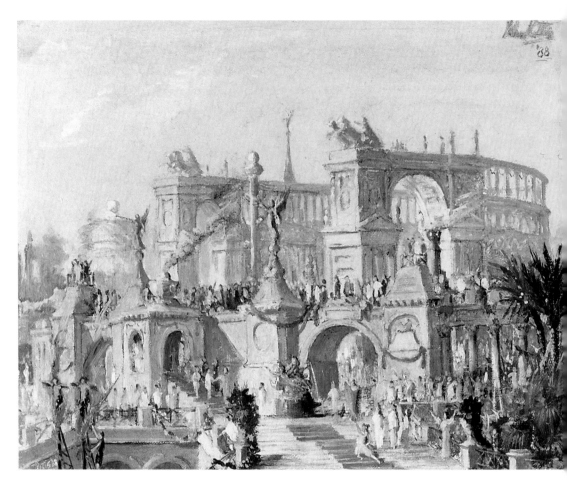

Crucifixion in Rome by John Rettig (1888). 8 × 10 in. Cincinnati Art Museum, Gift of Friars' Club.

The composition takes on a formal balance by deliberate positioning of each of the figures. There is no division of space, no baseline separating the earth from the sky. Instead the viewer is faced with a direct link to the crucified Christ, a head-on version of acceptance or rejection. There is no place to go.

The Crucifixion is a part of a series titled *Stations of the Cross.* All paintings of the series identify with the Renaissance era. Aside from Christ occupying the central location, thus dominating the scene, the three mourners' heads are raised upward with eyes gazing in awe at the torturous appearance of the crucified Christ. The Roman soldier's right hand is raised upward to complete the visual composition. The artist was careful to position the characters informally while simultaneously considering the final composition as one of formal balance.

Because the viewer must share time as a witness with five human beings, *The Crucifixion* should not be considered subjectively. All characters, though, are

closely knit and form a single unit; the work, therefore, can be readily conceived as a subjective experience.

John Rettig

This 1888 version of the Crucifixion, *Crucifixion in Rome*, is an extreme turnabout from the European Renaissance masterpieces. The artist, John Rettig, has forsaken the intimate relationship between Christ and the mourners. Instead he has displayed a multitude of people seemingly celebrating this tragic event. One needs to search for the crucified Christ among this abundance of human beings.

After a lengthy search, the viewer locates a small corner of the canvas where the artist has placed the crucified figures. Two figures occupy a small segment as a Roman soldier climbs the ladder leaning against the cross. The third crucified victim is lost amid the richly decorated and massive architecture. Numerous compositions fill the canvas. The overall sense of vitality and movement is enhanced by the apparent jubilation, or at least the callous enjoyment, of the spectators who overflow the foreground and stand atop buildings. One senses a crucifixion is a common event and engenders an air of indifference. The sky background is bright against the gigantic and lofty buildings. The style hints at the Impressionistic movement, in that hundreds of human forms dwell around the Crucifixion. But they are at a distance and consequently reveal no compassion. Nor do the crucified exhibit agony or suffering because of the distance placed between the spectators and the figures on the crosses.

Figures all seem daubed onto the canvas. They are defined but not identified. The several shadows and highlights tend to make the painting more complex and perhaps even confusing.

The title should give a hint of the type of composition. The site of the Crucifixion is Rome, not Golgotha, and thus an overflow crowd could be expected. Numerous statues unite with the human forms, thus adding to the already compact and overwhelming crowd. John Rettig has presented an uncommon approach for the 19th century. One would expect this during the 20th and 21st centuries. But nonetheless, *Crucifixion in Rome* makes for an exciting and bewildering journey.

Joseph Lindon Smith

The title of *Crucifixion, After Tintoretto*, a painting by Joseph Lindon Smith executed during the late 19th century, is not unusual since many American artists

patterned their early paintings after the European Renaissance painters. The areas of their influence varied from composition to color to technique. In composition, though, the Renaissance Europeans had the greatest sway over the American artist.

Tintoretto's compositions are provocative and compelling, and they are indeed a departure for the American artist. Painting an event which was never seen leaves the artist helpless unless assistance is available. In other words, secondhand information becomes essential. Studying original Renaissance works with the purpose of gathering knowledge forms a foundation for a personal modification of European masterpieces and eventual personal and meaningful expressions. The *Crucifixion, After Tintoretto* by Smith utilized the master's technique but slightly adjusted the positioning of the human images.

The image of the crucified Christ is located off center, but it is the basic stem of a triangular composition of the three crucified victims. The ladder leaning against the cross of Christ is significant because the accusers are about to participate in forcing a sponge of vinegar into the mouth of Christ. The triangular composition consists of five human beings and although it basically stems from the foreground, their presence extends upward to consume the background.

Roman soldiers gather around the base of the three crosses but are given little importance because of the strength of the figure of Christ. All three crucified victims overlap to form a close-knit singular composition.

Albert Pinkham Ryder

The Way of the Cross, a painting by Albert Pinkham Ryder, underwent several changes before a final statement was made. Born in 1847, Ryder, a noted landscape artist, never lost the need to paint the cross and the crucified Christ. In his 1893 version, the crucified Christ is not revealed. The simple composition reveals Mary on a mule visiting with a human figure resembling Christ. The figure's left arm is raised heavenward toward a small crucifix which rests atop a tall wooden pole as if to suggest the life of Christ.

There are several interpretations of the meaning of Ryder's *The Way of the Cross*: it represents Christ's Ascension into Heaven, his enclosure atop the vertical plank of wood, or his loving mother who will accompany him after his Resurrection. The work is deceiving because of the varying degrees of change from the initial drawing to the final painting. Compositionally, Ryder's painting is divided into three major working areas. The figure of Mary on the mule and the figure of Christ share the background and the middle ground. The sky background is intercepted by the figure of Mary on the mule, and the middle ground is occupied by Christ.

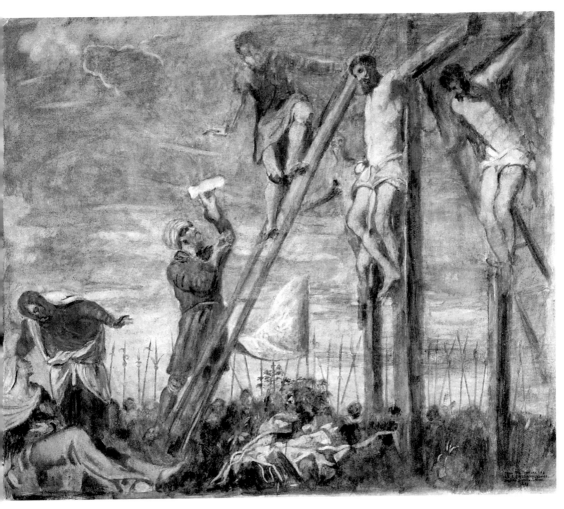

Crucifixion, After Tintoretto by Joseph Lindon Smith (1889). Watercolor over graphite on off-white wove paper. 35.5 × 41.7 cm. Courtesy of the Fogg Art Museum, Harvard University Art Museums, Bequest of Denman W. Ross, Class of 1875. Photograph by Allan Macintyre.

The foreground is a highlighted area which reflects the sunlight and time of day. The divisions of lights and darks appear so casual that they suggest a meeting of significant silence. The facial gestures of both figures are those of mute joy. After an extensive study, the viewer is apt to consider the visual distance between the two figures as essential to the composition as well as the meaning of the communication. One wonders what thoughts prevail. No hints are given; the conclusion is left to the observer. The fact that Ryder painted several versions of this theme suggests his need for the perfect or ideal execution.

Although a preliminary sketch for a future painting, *The Story of the Cross*, a drawing by Albert Pinkham Ryder, is a complete expression. Ryder has revealed the birth and death in his notion of the Crucifixion. What is depicted is the flight

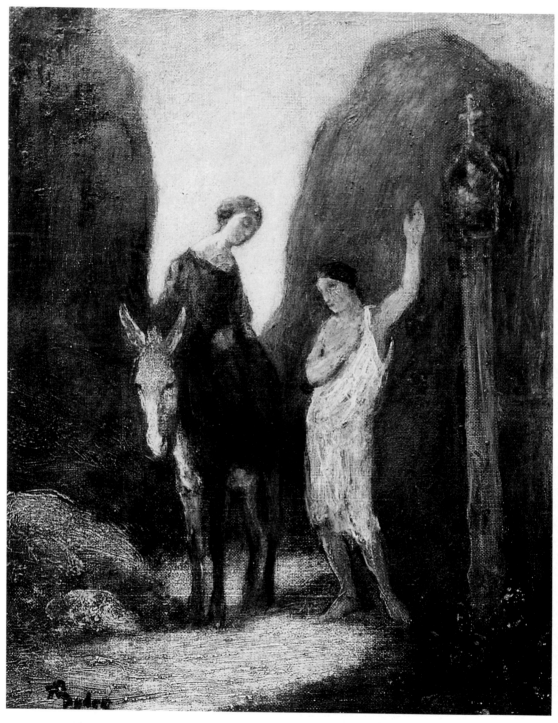

Above: The Way of the Cross by Albert Pinkham Ryder (date unknown). Oil on canvas. 14⅛ × 11⁵⁄₁₆ in. 1930.297, gift of anonymous donor. ©Addison Gallery of American Art, Phillips Academy, Andover, Mass. *Opposite: The Story of the Cross* by Albert Pinkham Ryder (1887). Pen and bluish black ink. 19.3 × 14.5 cm. The Art Museum, Princeton University. Gift of Frank Jewett Mather, Jr. Photograph ©2002 Trustees of Princeton University.

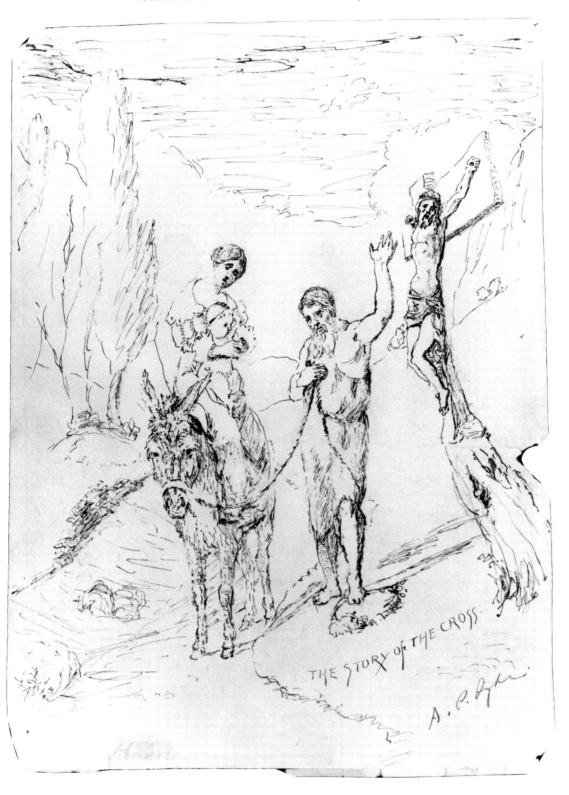

THE STORY OF THE CROSS.

into Egypt which dominates the central portion of the drawing. Mary and the child Jesus astride a mule are led by Joseph who elevates his hand in a gesture of rest. This same gesture points the viewer's attention directly to the crucified Christ, thus completing the life span of Christ from birth to death.

Ryder's notion to include both the birth and death of Christ in a single expression is rare. Each idea is worthy of full attention, but to combine the two challenged Ryder to blend the joy of birth with the agony of death—two opposing emotional states—in a single, complete and satisfying drawing. The pen and ink method was used in a brisk manner merely suggesting the presence of objects such as trees, rocks, sky and terrain. Details are reserved for the human characters. In *The Story of the Cross*, it is difficult to ascertain the importance of each character. Which figure and event are foremost?

Occasionally, a sketch records scribbles and scratchy lines which have no meaning but are subconscious marks or doodles. Other times, they are an attempt to fill space with elements of realism. The latter is suggested here in Ryder's drawing.

The crucified Christ may not be the dominant figure, but his figure being positioned off center demands unusual attention. Christ is in agony as his face reveals extreme pain. Ryder depicted the birth and death of Christ, but the addition of the Resurrection and the Ascension could have created a full circle. Each miraculous event would have changed the expression drastically.

John Singer Sargent

Seldom did the artists of the 19th century paint religious themes. An exception was John Singer Sargent, a painter of the late part of the century, who was noted for his elegant portraits and American landscapes. Sargent painted *Tyrolese Crucifix* as a segment of an outdoor shrine. It is a crucifixion without an audience of mourners and spectators. The cross to which Christ is nailed is sheltered by an overhang which is a part of the outdoor shrine.

The figure of Christ is traditional with head held high suggesting that the end has not yet come. Blood streams down his side and legs and is particularly profuse on the hands and feet. Thorns have caused blood to ooze freely about the forehead. The figure is anatomically correct but takes on an emotional sense because of the distortion caused by the intense suffering.

Tyrolese Crucifix is an unusual composition because it represents a segment of the whole. Although the entire body of Christ is expressed, missing from the

Opposite: Tyrolese Crucifix by John Singer Sargent (1914). Watercolor and graphite on white wove paper. 21 × 15¾ in. The Metropolitan Museum of Art, Purchase, Joseph Pulitzer Bequest, 1915. (15.142.7)

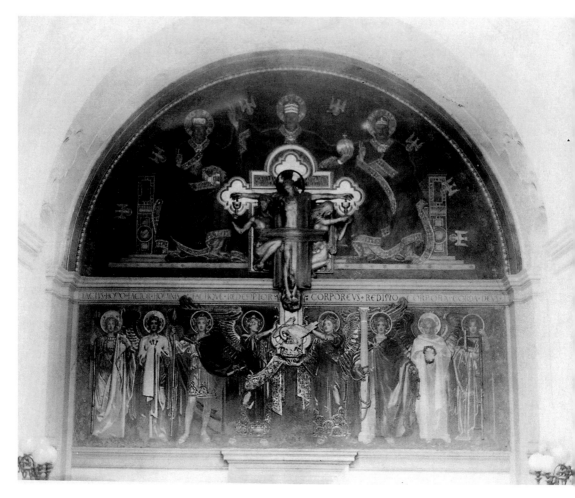

The Dogma of the Redemption by John Singer Sargent (1896). Mural. Courtesy of the Trustees of the Boston Public Library, Boston, Mass.

painting (but common to most depictions of this theme) is the audience, which has added to the emotional intensity of the victim's suffering. Behind the wooden cross is a tree which consumes much of the background. Sargent has allowed a large section of the background to be represented by the sky area. However, he has cleverly included bent-down branches of the tree to occupy a part of the background. The move is subtle, but effective. Because of the tree's unique positioning there is a wholeness, a oneness to the painting.

Furthermore, the heavy overhang of the shrine is downplayed by the inclusion of the tree branches. The overhang, with its strong diagonals, is held in place by virtue of the color nuances covering the inner structure of the shrine. The entire left segment of the painting is laden with heavily textured areas of bark; this seems to reveal content which could easily be mistaken for suggestive human distortion. Even though the figure of Christ is a close-up view, the painting sus-

tains an objective appearance. The figure is centrally located but because of the detailed elements present in the tree form and segments of the shrine, a once subjective appearance becomes objective. Details draw attention away from the figure thus creating a mixture of compositional attitudes. Sargent has not explained the reason for this opposition. Thus, it is left to the viewer to form a personal interpretation.

The Dogma of the Redemption, by John Singer Sargent, is a mural measuring 23 feet wide and 26 feet high. Although the mural was installed in 1903 in Boston's Public Library, it had been finished a few years before, possibly in 1896. It was awaiting the bronze figure of Christ with Adam and Eve, which was identical with that of the mural. Being a commissioned work to fit architectural and liturgical limitations, the huge mural lost some of the emotional impact initially envisioned. The semi-circular work has the crucified Christ sustain the central position. Adam and Eve are located to the left and right respectively, each holding a chalice into which Christ's blood drips from his spiked hands.

Below the foot of the cross are angels, each bearing a halo symbolizing sainthood. The influence of the European Renaissance is evident in the compositional use of mourners and Roman soldiers. There is no action or emotional gesture on the part of the participating figures. Facial features are stoic and reflect the aftermath of a tragedy. In spite of the immense working surface, each human form is dealt with in detail. Lace and intricate garments clothe each individual.

The Dogma of the Redemption is formally balanced. One views it as a complete expression, as no one part supersedes another. It is highly decorative. The upper circular segment of the mural features angelic creatures spaced equally apart to form a background balance. A figure draped in a white robe holds the crown of thorns which Christ wore during his ordeal in reaching Golgotha. At the base of the cross located in the lower foreground are two angels pictured with wings of strength representing the stability of the entire expression.

Louis Kurz

Painted in 1897, *The Crucifixion* by artist Louis Kurz reflects the memories of the late Italian Renaissance painters. Kurz has positioned the crucified Christ in a classical pose. A single spike has nailed the victim's overlapped feet to the cross, and a spike is thrust through each hand. The artist has pictured the two adjoining victims in a different way than he pictures Christ. They are roped to their crosses, hands and feet, and their bodies slump forward. The second thief to the right of Christ reveals only segments of his body because of the rear of his cross blocking the view. The trio of crosses, although purposely set at uneven

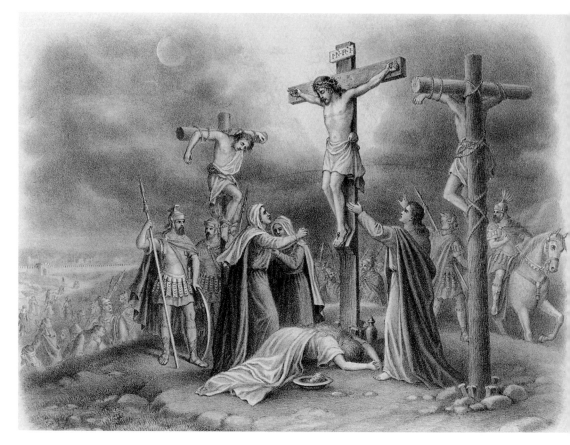

The Crucifixion by Louis Kurz (1897). Oil on canvas. Library of Congress, Washington, D.C.

levels, form a circular composition which includes the numerous mourners and accusers. The three Marys grieve as they reach out to the crucified Christ. A single figure lies upon the earth's surface in total exhaustion. Other figures include Roman soldiers standing guard over the proceedings. Louis Kurz has painted the sky to set the emotional tone of the painting and rounded out the foreground to complete the circular composition.

The strong verticals of the three crosses and the surrounding standing figures are compensated for by the horizontal landscape. Even though several compositions comprise the whole, they act as a unifying force by becoming a single unit or aspect. Each group of figures is a complete composition. The spacing and overlapping of each make for a free-flowing exhibit on a single working surface.

Although the subjective aspect is present, the viewer is forced to acknowledge each group of figures singularly. After sustained study in an objective and informal manner, one becomes absorbed by the entire composition. Details are a significant aspect of his work and because objectivity consists of details, one

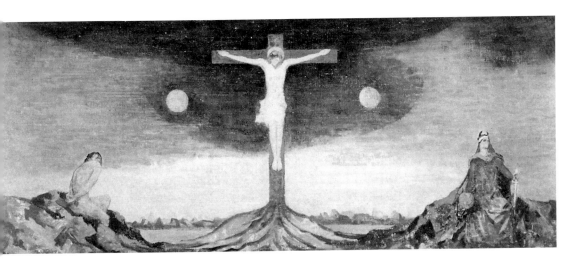

Mystical Crucifixion by Augustus Vincent Tack (date unknown, possibly 1898). Oil on canvas on plywood panel. 21⅛ × 9⅛ in. The Phillips Collection, Washington, D.C.

would view the work in a partially segregated manner. But that is the beauty of *The Crucifixion*.

Kurz has focused on the major figures—Christ and the three Marys. The viewer may be slow in recognizing the triangular composition. The remaining figures are of secondary importance. However, they not only add to the composition but also act as visual boundaries, holding the painting within the framework of the working surface.

Kurz was born in 1833. Most of his work was painted during the later part of the 19th century and the early years of the 20th. *The Crucifixion* is a masterful piece of art and deserves a major place in 19th century American painting.

Augustus Vincent Tack

Augustus Vincent Tack's paintings have been classified as undated even though most of his religious works were listed with dates in the late 19th century. His painting titled *Mystical Crucifixion* is totally personal and free of any European influence. Christ sustains the focus of attention, occupying the direct center of the canvas. In fact, his figure divides the painting into two equal parts forming adjacent rectangular shapes. Formal balance is obvious since Christ's form is balanced on each side by what appears to be a pair of suns or moons slightly covered by a dark cloud. Christ's white form creates a sharp contrast between himself and the surrounding cloud. The sky is still and mute. It seems that death has occurred.

Christ sustains a formal balance equal to that of the cross. It is not a dramatic

scene. Christ is alone except for a single figure positioned on each side of the cross adding to the formal balance. The environment is a desolate landscape made up of heaps of dirt and rocks. The person to the right of the cross is unidentified. Seated on a bed of rocks, his hands tied, he gazes upward toward the crucified Christ. A second figure located to the extreme right of the canvas resembles a Roman soldier with a sword held tightly and perpendicular to the earth's surface; he appears to be guarding Christ on the cross.

Tack's *Mystical Crucifixion* is indeed mystical. It is personal and intimate with no weeping mourners, sinners or curious spectators on hand. It sustains a surreal atmosphere because of the lack of spectators; it's as if the artist wanted no interference with his personal expression of the Crucifixion. Christ is hung in a traditional manner and reveals no signs of torture or suffering. However, the strangely formed balance of the painting catches the viewer off guard. In spite of the loneliness reflected in *Mystical Crucifixion*, the viewer becomes more involved because of its peculiar arrangement. *Mystical Crucifixion* certainly seems to be spiritually motivated, resulting in a highly individualistic approach. It is indeed unlike much of the painting done on this theme during the 19th century.

Fred Holland

Fred Holland has used his own physical body to represent Christ on the cross. Each of his three portrayals is executed in a traditional manner and all three are quite similar in composition. In *Crucifixion No.1* the figurative image is a complete profile. There is nothing to witness but the singular form upon a wooden cross. No bloodshed, no mourners, no Roman soldiers, no skulls at the foot of the cross are witnessed. The background is mute with no signs of an oncoming storm, nor has darkness enveloped the land.

One may sense a lack of profound devotion because Holland used his own body to represent the event. However, it was his way of atonement. Holland was an example of a man substituting his own body for that of Christ, but only as a symbol. He re-enacted an event; it was a kind of play, or a little reproduction of history.

The profile strongly suggests a three-dimensional view even though only two views are envisioned. The cross is centrally located, dividing the picture into two vertical parts. The cross is hoisted high above the earth's surface, making it appear as if it were reaching heavenward.

This is a platinum photographic print as are the two that follow. The pose

Crucifixion No.1 by Fred Holland (1898). **Photograph. Library of Congress, Washington, D.C.**

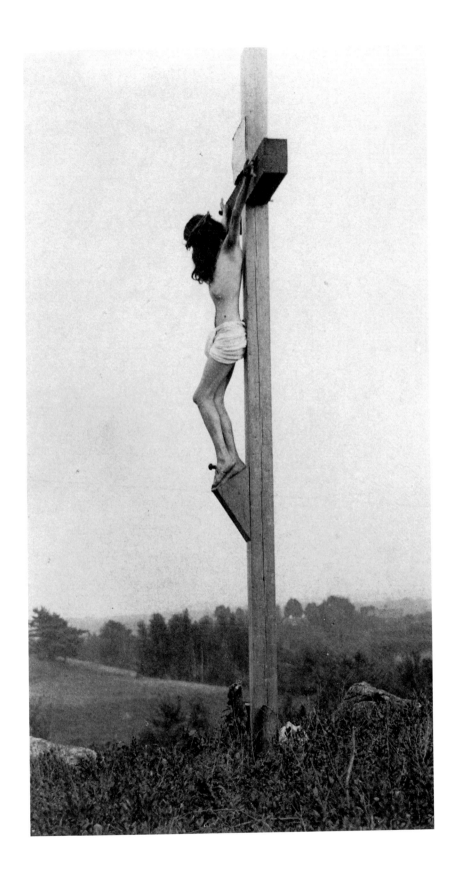

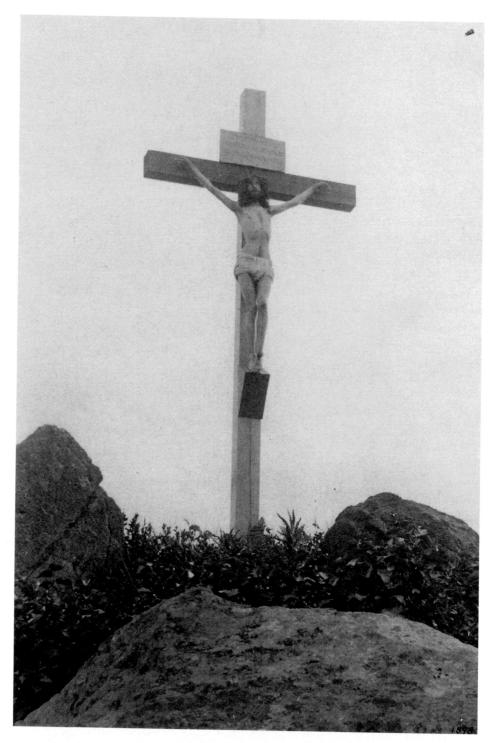

Crucifixion No.2 by Fred Holland (1898). Photograph. Library of Congress, Washington, D.C.

of the model portraying Christ differs from the position of Jesus painted by those artists who didn't use models. Not using models, of course, allowed the artists full freedom to portray the image of Christ in any manner they preferred. Their aim was to deliberately distort the human body, in order to fully convey the agony of Jesus on the cross.

Fred Holland's *Crucifixion No.2* differs only slightly from his *Crucifixion No.1*. An angle switch is the major change. Since he has presented a frontal view of the figure on the cross, one is able to witness a full view even though it appears to be at a distance. Instead of splitting the expression into vertical planes, Holland has used the cross as a rectangular shape within a rectangular framework. The horizontal crossbar to which the hands are attached intercepts the vertical segment of the cross to form a diamond shape as the eye travels from point to point. The figure is positioned above eye level so that the viewer is forced to raise his head upward to appreciate the event fully. Little concern was given to a deliberate composition. The positive aspect was simply placed over the negative aspect. The cross again is stationed in isolation, hoisted atop barren terrain. Since Holland's Crucifixion is a performance, it lacks the brutal realism that would otherwise be expressed by original artists.

The angle of the cross when visually experienced can change the entire approach for the viewer. A view from either side creates an unusual three-dimensional effect on a two-dimensional surface. It defines the purpose of sculpture and gives the impression that the figure is revolving so that all sides can be observed when actually only one side is exposed. When viewing from a frontal angle, the background remains as intended; that is, the background and the foreground including the figure offer no change in concept. *Crucifixion No.2* is attached firmly to the earth's surface, forming two definite segments—the background and the foreground. The paramount element is the figure on the cross, which becomes a part of the foreground even though the figure and cross extend high into the background sky. *Crucifixion No.2* is a traditional pose and may be considered classical in its interpretation.

In *Crucifixion No.3*, the crucified form is not alone. And of course, one wonders about the purpose of the spectators' presence—curiosity, sorrow, contemplation, duty or some unexplained reason. It is possible that the viewer's attention and concern may be equally shared among the five figures. In other words, the crucified form is no more important than any one of the four figures in the foreground. To alter this situation, all figures at the foot of the cross would have to be eliminated so that there is a complete and total absorption in the figure on the cross.

In *Crucifixion No.3* there is an objective expression. As each figure is removed, the viewer becomes nearer to God, not in a visual sense but in a contemplative. The removal of the second and third figures would make the communication more personal. As the last figure is removed, only Christ on the cross and the viewer remain—two people face to face as the viewer is positioned outside the picture plane. Thus, the event becomes an act of atonement.

The obvious difference between Fred Holland's *Crucifixion No.3* and the two previous ones is the addition of four humans who form a rectangular shape that joins a vertical rectangular shape. The background remains the same. The four figures are grouped in twos and equally distant on either side of the cross. A totally subjective expression is now an objective one. The viewer is forced to acknowledge the four figures as quickly as the figure on the cross. The four figures are centrally positioned although a bit of monotony creeps into the picture as all figures are standing upright and in doing so form a single unit. Holland avoided the temptation of a formal balance which is less exciting than an informal arrangement. The figures are added for interest to the figure on the cross. There is no compassion among the viewers as they look upward into the face of the crucified.

Everett Shinn

Crucifixion by Everett Shinn was painted during the late 19th century or early 20th century. The watercolor technique allows for a loose composition, and as such, the work retains an active movement throughout. For example, the crowd of mourners relate to the Abstract Expressionist movement. Smears and blotches of color define the audience and the background. Roman soldiers are slightly identified as they pose beneath the cross upon which Christ is crucified. The sky is brightly painted as if to suggest the coming of the Ascension. It also suggests the time period before the actual death of Christ.

The three crucified figures are hoisted high above the spectators below. The crucified Christ is defined because of his central location on the picture plane. All three figures are extremely distorted because of the intuitive process of painting. No signs of suffering, agony or despair are evident partly because of the distance separating the crucified figure from the weeping audience and because of the spontaneous application of pigment.

Far from the traditional expression of the Crucifixion, Shinn has captured the essence of the event through the intuitive approach. Because of the small working surface, a mere 5 by 3 inches, the brush is readily controlled and errors easily corrected. Shinn's *Crucifixion* is dramatic, an effect created by the brushwork as well as the unusual composition. The audience creates a circular design which acts as a baseline upon which all activity is based, and the vertical extension of the crosses suggests a rectangular composition which is compatible with the surrounding audience. The most unusual feature of Shinn's expression is the height of the crosses. They appear to be ascending upward toward heaven.

Opposite: Crucifixion No.3 by Fred Holland (1898). Photograph. Library of Congress, Washington, D.C.

Crucifixion by Everett Shinn (date unknown). Watercolor. 5⅝ × 3½ in. Museum of Fine Arts, St. Petersburg, Fla. Gift of Eleanor M. Miller.

THE 20TH CENTURY

During the 20th century there were no patterns or styles to follow. In fact, the 20th century artists became so personal and free from all intended purposes and influences that it was difficult to determine the meaning of the subject matter. Regardless of subject matter 20th century artists clung to their current styles. In other words, if the artist favored the optical illusion movement, the theme of the Crucifixion would be executed in optical illusion style. The subject matter seldom dictated the style.

The artists of the 20th century were influenced by the Depression of the thirties and World War II, which became the motivating forces of a religious attitude and approach. In 1923, well in advance of the Depression, George Bellows painted a crucifixion scene still showing Renaissance influence and 19th century styles. As the Depression descended, however, styles were changing. Artists such as Nordfeldt, Romano, Nagler, and Rattner painted the theme expressionistically during the thirties. However, Realism continued to be the primary style.

After World War II ended, Abstract Expressionism startled the art world. Introduced by Jackson Pollock, the movement gathered several prominent followers including such greats as Hofmann, de Kooning, Guston, Rothko and others. The movement continued throughout the 20th century, which ended with the portrayal of cityscapes, still life and landscapes classified under the subheadings of Super-realism, Photo-realism, and Ultra-realism.

Realism and Abstract Expressionism ruled the 20th century. Optical Art and Popular Art, better known as Op Art and Pop Art, made appearances but decreased in popularity over the years.

Jesus Is Nailed to the Cross by John J.A. Murphy (1921). Woodcut. 3 × 3½ in. Herbert F. Johnson Museum of Art, Cornell University, Ithaca, N.Y. Bequest of William P. Chapman, Jr., Class of 1895.

John Murphy

John Murphy's woodcut titled *Jesus Is Nailed to the Cross* and dated 1921 looks immense in spite of its small size of 3 x 3½ inches. The mountains surrounding the event appear to swallow up the figures attending the forthcoming tragedy. And yet, each individual image cut into the working surface is articulate and flawless. Three simple lines form the cross, and each figure is defined and identified — the mourners, the Roman soldiers and the figure nailing Christ to the cross. And even in spite of its smallness, a halo is produced to surround the head of Christ.

Murphy seemed more concerned with a successful display of the event in

Jesus Dies Upon the Cross by John J.A. Murphy (1921). Woodcut. 3 × 3½ in. Herbert F. Johnson Museum of Art, Cornell University, Ithaca, N.Y. Bequest of William P. Chapman, Jr., Class of 1895.

the woodcut medium than he was with revealing the agony and anguish of Christ. The physical gestures displayed by the figures are a credit to the artist's patience and professional workmanship. There is a bit of competition between the mountainous background and the event itself. In this black and white work, gray tones are created by positioning white lines parallel to one another — an area is lightened by the lines being located closer to one another. The unusual amount of black, it would seem, ought to devour the figures in the foreground, but it does not. In fact, the expanse of black is essential to reveal the importance of the event about to take place as well as blending the foreground and background into a oneness of purpose.

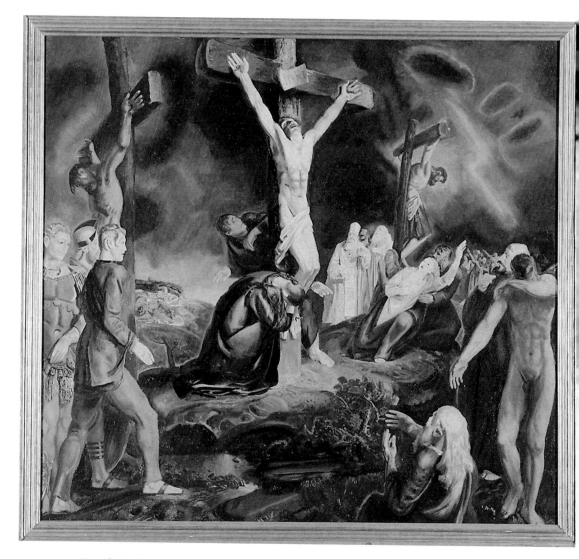

Crucifixion by George Bellows (1923). **Oil on canvas. Collection of Lutheran Brotherhood, Minneapolis, Minn.**

Jesus Is Nailed to the Cross is stark. One notices the black surface immediately; it is only in the second glance that the meaning of the title becomes brutally obvious. Murphy was careful to locate, with an informal style, the areas of solid black. There is life in the background. The artistic expression became more important than the message the event itself transmitted.

In his woodcut *Jesus Dies Upon the Cross*, John Murphy has altered the background from an environment of mountains to one of total darkness. His meticulous arrangement of figures on a small working surface exhibits a display of accuracy and perfection. It is unusual for an artist to successfully depict personalities in so few lines. Three crosses appear in this woodcut, with Christ assuming

the central position and flanked by the two crucified criminals. The image of Christ hangs in the traditional manner, ribs revealed, head bowed forward and halo surrounding his head. The two thieves are not nailed to their respective crosses: their arms are tied behind the crossbars.

The five kneeling figures in prayer all differ in their postures. Hands folded, heads bent forward and downward, these figures resemble the three weeping Marys and Nicodemus. To the far right of the expression is a line-up of mourners represented by a series of vertical lines, which, through Murphy's handling, suggests a multitude of spectators.

It is interesting to note that the artist used no baseline onto which the figures and crosses would be anchored. Instead, by some unusual arrangement the figures appear to form an invisible baseline by their very presence. There is a oneness, a sense of companionship among the figures. The foreground, traced by a baseline that one only imagines, and the background are both black, thus introducing a sense of a personal and intimate relationship between the two environments. The entire expression is black except for the most important aspect, that of the crucified Christ, which is expressed in white, creating a sharp contrast between Christ and the background. It seems to represent the light emerging out of the darkness.

George Bellows

Crucifixion by George Bellows has a definite Tintoretto influence. Dated 1923, the painting reveals the crucified Christ flanked by the two criminals executed in the same manner. Bellows' rendition differs from those of his contemporaries in the physical posture of the central character. Instead of dropping the head forward, Bellows has hung Christ's head back. Hands also differ. The hands of Christ appear relaxed as if surrendering life. For the sake of composition Bellows' portrayal of the two thieves differs considerably from his portrayal of Christ, forming a rectangular composition upon a rectangular surface.

The figure of Christ is surrounded by an audience of sinners and accusers. The figure kneeling at the foot of the cross and whose face is hidden from the viewer adds to the awesome event. As lightning strikes, compounding the drama, spectators shrink from the sight. Christ's pierced side shows no sign of blood, but his hands and feet do.

Several compositions comprise the whole. Each crucified form has an audience, but attention is directed toward the crucified Christ. Shame and guilt are reflected in the facial features of the witnesses. The crucified Christ occupies the central position of the canvas, demanding immediate attention. Subtracting the audience would result in a more dramatic expression because the viewer would

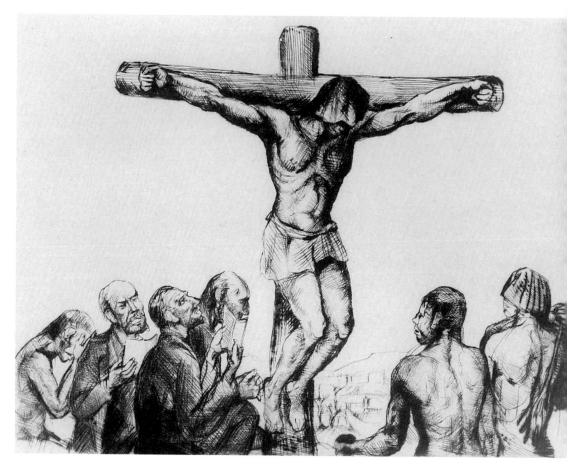

Penitentes: The Crucifixion by B.J.O. Nordfeldt (c. 1924). Drypoint and etching. Gift of Mrs. B.J.O. Nordfeldt, in the University of New Mexico Art Museum.

then have a total view of the terrifying subject. The figure of Christ would share the picture with no one and thus would become an unimpeded line of communication between the crucified Christ and the viewer. The painting would reverse its objective nature and become a subjective experience.

George Bellows' *Crucifixion* could well be classified as a Renaissance painting resembling that of Tintoretto and El Greco. Painted during the early days of the 20th century, it reflected the state of religious art in America.

B.J.O. Nordfeldt

B.J.O. Nordfeldt's 1924 *The Crucifixion* (not pictured here) is not the image of the crucified Christ. Two crucifixes are portrayed: one for the actual cruci-

fixion of the sinner which occupies the center of the canvas, and the small crucifix of Christ held by the figure to the left of the painting. The crucified sinner is flanked by two brothers whose heads are bowed in prayer for the soul of the accused.

There is a silent communication and a symbolic reference made to the crucified Christ. As the figure to the left holds up the crucifix of Christ toward the accused, the message of Christ is made known. That is, there is a resemblance between the two crucified figures, a form of mutual death both on the human level. In a sacrificial sense the sinner is murdered in a manner similar to that of Christ.

The *Crucifixion* is an incised plate and *Penitentes: The Crucifixion* is a print made from this incised plate. *Penitentes: The Crucifixion* is a silent and somber representation of the event. It also compels a profound sense of compassion. The ironic display of a double exposure of the crucifixion of the sinner and that of Christ projects a symbolic connection of the two crucified forms. This is a 1924 production.

In *Penitentes: The Crucifixion* the sky is mute, which creates a separation between the foreground and background. However, the figure of Christ is dramatically expressed. His hands are clenched, suggesting an effort to leave the scene, as if the need to escape the torture and humiliation has grown stronger.

His head is bent forward, reflecting the hour of death, while the mourners gaze in wonder. The six watching figures are stunned as they gaze at the body of Christ. Nordfeldt has overlapped each figure except for the faces, which reflect anguish and sorrow.

Christ's body reveals few signs of the bloody torture. As in all of Nordfeldt's versions of this theme, the feet remain apart from each other. Other artists have overlapped the feet and fastened them with a single spike. There is little concern given to the background; thus, Nordfeldt has neglected an opportunity to augment the atmospheric conditions.

There is a bit of the early German Renaissance in Nordfeldt's *Penitentes: The Crucifixion*. It differs because of the muted sky, an empty space which serves only as a compositional device and invites an immediate response to the agonizing event. Although the mourners are pictured only from approximately the waist up, the viewer is treated to a full scope of the event.

Nordfeldt's 1947 version of the image of this theme is simply titled *Crucifixion*. No mourners witness the event. Only a rocky base or foreground acts as a single baseline for the three victims.

Christ holds the central position in a frontal view as the two criminals hang in a three-quarter view. Christ's head is bent forward, allowing the crown of thorns piercing his brow to be viewed.

Although Christ's feet are nailed to the cross, the criminals' feet are roped to their crosses, as are their hands. Nordfeldt has turned the faces of the criminals toward the viewer, thus establishing a visual link to the viewer. In each of the

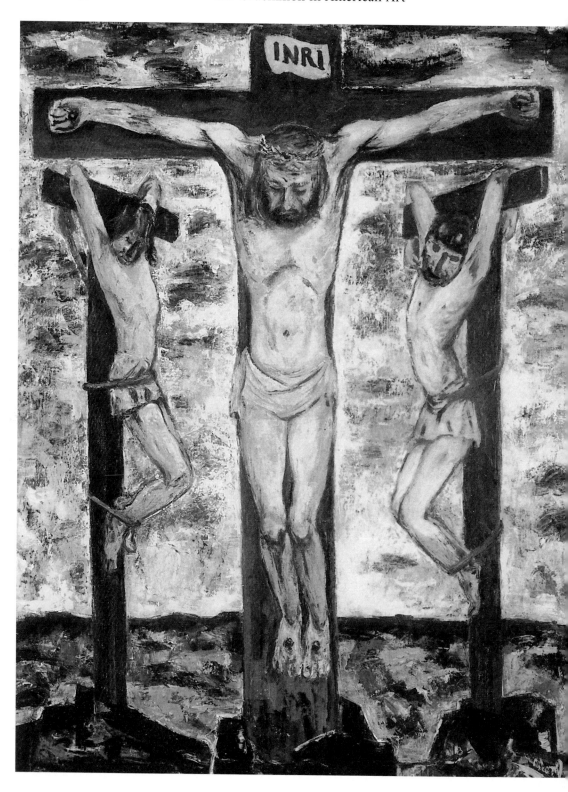

three figures the head is hung downward, an exhausted posture that again suggests the hour of death.

Nordfeldt has used the background to unite background and foreground in an Expressionist manner, while deviating slightly from that technique with the figures. In each figure the knees are bent forward as the bodies take on torturous imagery.

The dark crosses seem to grow directly out of the earth and form a vertical rectangular shape. Even though the figures tend to blend with the background, the dark crosses to which the figures are attached form a sharp contrast to the background.

To classify or define Nordfeldt's style one should consider both Realism and Abstract Realism. *Crucifixion* leans toward Realism although there are hints of Abstractionism included. Nordfeldt generally expressed the bare essentials in his paintings, and one responds immediately. Trees are naked, waves of water are broadly swept and are common, and a deliberate lack of details makes emotional dramas of the most mundane themes.

Crucifixion with Birds by B.J.O. Nordfeldt reveals the stress sustained by the neck and shoulders as Christ's head falls forward. The severe suffering has caused an extreme distortion in both arms. His head is crowned with thorns. There is no halo, which was symbolic of holiness but which contemporary American artists seldom used. Instead the crown of thorns has become more significant.

The base of the cross stems upward from a rocky foreground. This painting is emotionally charged and compositionally in perfect balance within the confines of the working surface. The crossbar occupying the upper portion of the painting matches the rocky formation of the foreground. In spite of the movement of the swirling flock of birds evident in the background, *Crucifixion with Birds* is still a subjective expression. The viewer is attracted immediately to the crucified Christ as the divisional point of viewing. Because his head is bent forward, the crown of thorns becomes readily noticeable as well as the shadows partially hiding his face.

The background and foreground have little effect upon the response of the viewer because of the disfigured Christ and the central location of his body.

The title is noteworthy, but it is difficult to determine its total meaning. The birds are symbolic. At a glance they appear to be shortened daggers. Then again, they could be birds of peace, suggesting the Resurrection. Interpretations may also include vultures. Or the artist could have a secret and personal reason for the birds which has no bearing on the theme whatsoever. However, the birds create excitement within the otherwise mute background. They surround the body of Christ and serve as a compositional aid. Since the majority of the birds flock around the upper portion of the cross, they appear to be attackers of the body of

Opposite: *Crucifixion* by B.J.O. Nordfeldt (1947). Oil on canvas. 132.1 × 101.6 cm. Worcester Art Museum, Worcester, Mass., Museum Purchase, 1947.13.

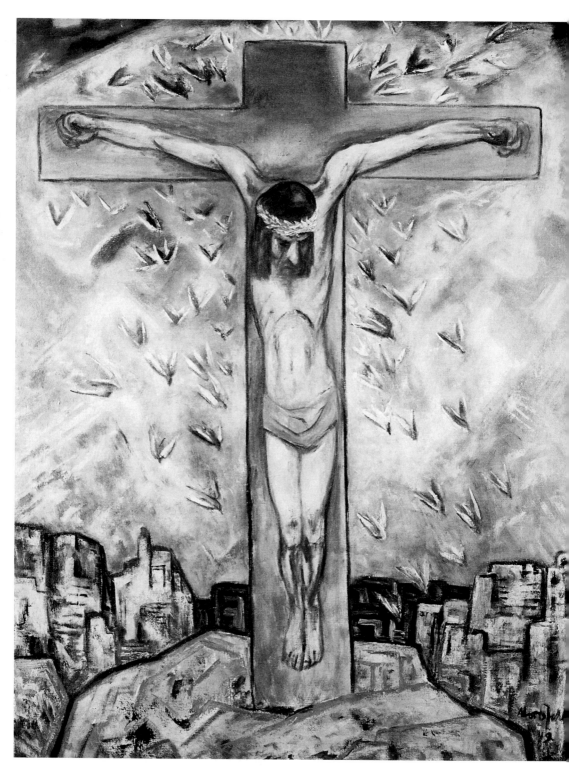

Crucifixion with Birds by B.J.O. Nordfeldt (1949). Oil on canvas. Collection of the Marion Koogler McNay Art Museum. Gift of Mrs. B.J.O. Nordfeldt.

Christ. Surrounding the upper section of the cross, the birds create a visionary response to the upper torso of the figure. Christ's hands are cupped, as if he is attempting to release himself from the cross.

The rectangular shape of the crossbar unites with the birds in flight to produce a circular composition. As the eye follows the figure of Christ downward, a second composition is formed by the combination of the foot of the cross and the rocks in the foreground. Formal balance occurs when foreground and background form identical rectangular shapes with the cross, seemingly holding the two areas in check. It is as if both foreground and background were painted with the cross and the figure of Christ placed onto the canvas to form a oneness, a total composition. Both foreground and background recede, and the crucified Christ remains the focal point of the painting.

Nordfeldt was a Swedish immigrant who spent much of his life as a theatrical designer. It was not until late in life that he devoted his entire energy to painting. According to historian Van Deren Coke, Nordfeldt said, "I will give my time, the rest of the way, to the essence of the thing we call painting. I will grasp at the very heart of painting."*

Prentiss Taylor

A lithograph titled *Christ in Alabama*, executed by Prentiss Taylor in 1932, pictures an African American Christ crucified. An African American woman is seated at the foot of the cross. Rows of cotton dominate the foreground. Taylor has reversed the figure and cross combination. Christ is black and the cross is white.

At first glance, the Crucifixion exhibits a notion of the Resurrection. Christ's hands are not nailed to the cross but only positioned in the appropriate area. His arms are raised heavenward, suggesting a plea of mercy. The figures of Christ and the mourning woman show no signs of agony or anguish because the artist has purposely avoided such physical signs by using an opaque technique. The inner structure of the two figures is ignored by Taylor. Instead, the litho crayon creates shadowy effects such as silhouettes. No identification of bone structure or facial gestures is evident.

Prentiss Taylor has appropriately united the foreground and background by using the same technique for both areas but has toned down the background so that the two figures remain dominant. The artist has raised Christ's head upward instead of portraying it in the traditional downcast posture. The title, *Christ in Alabama*, is appropriate. The lithograph includes cotton plants, indicating the location of the crucifixion and suggesting that the Negro race has been crucified

From the book Nordfeldt the Painter, *published by the University of New Mexico Press, 1972.*

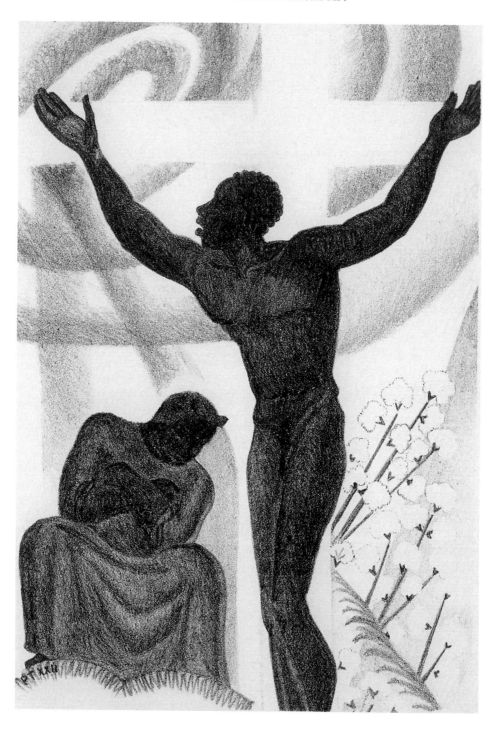

Christ in Alabama by Prentiss Taylor (1932). Lithograph. Library of Congress, Washington, D.C. With permission of the Estate of Prentiss Taylor.

for centuries. In actuality, the location could be anywhere or everywhere and the crucified Christ could be of any ethnic origin.

Christ in Alabama is a simple arrangement of two human figures; but, without sacrificing their importance, the artist has created a oneness of the foreground and the background.

John Young-Hunter

The title of John Young-Hunter's 1927 painting, *Christmas Eve with the Indians of New Mexico* (not pictured), is an honest one. But when the work refers to the theme of the Crucifixion, one wonders where the emphasis lies. And yet after a search, one realizes that the artist has combined the birth and death of Christ in a simple expression. We see the mother of Christ on the eve of the birth of Christ, and the Crucifixion on parade represents the death of Christ. This is a splendid painting and records the agony of Christ even though the artist has expressed a crucifix rather than a Crucifixion.

The crucifix is an icon and is being heralded as the risen Christ. Compositionally, the focus is on the image of Christ on a cross, which is hoisted high in an overlapped fashion with the person of Mary. The focal point is marked slightly off center. The five Indians to the left guiding the procession are tilted inward toward the image of Mary. A sixth Indian garbed in white leads the parade from the opposite side.

John Young-Hunter's painting is compact and complex. The artist has refused to utilize all space with objects or images. He created a seemingly empty area at the base of the painting but because of the rather complex composition, the empty space is welcome. One senses movement among the Indian marchers. However, the positioning of the major figure creates a sense of stillness— movement stopped momentarily to permit meditation. Seldom does an artist combine the birth and death symbolically in a single composition. John Young-Hunter has blended the two extremes in a provocative manner.

John Young-Hunter's drawing titled *Indian with Crucifix* (not pictured) appears to be a preliminary sketch for a future painting. Whether incomplete or final, its exquisite structure and position on the working surface enable one to appreciate fully the potential it offers as a future work. If planned as such, it may pass as a complete and detailed drawing. However, the artist has suggested an unfinished work and a preparation for a procession or parade. One expects other figures to be added so that the negative space becomes positive.

Indian with Crucifix is a 1927 drawing revealing details which would appear in the probable future work. There are no suggestive lines, incomplete shapes or guess work. The drawing is direct and complete in details. The only concern would be whether he has allowed space for additional figures. If so, the viewer

must then appraise the work as it would appear when finished. His use of the contour lines defines his accuracy in drawing the human form, and the medium of charcoal affords readily applied shading.

The single head drawn to the right side of the working surface suggests a duplicate and more finished portrayal of the head of the marching figure who holds the crucifix. Accents of white are scratched from the surface of the gray-toned background. This technique also acts to provide highlights and accents.

Details are reserved for the faces and the crucifix so that the focus is more immediate. Line is most important because with the human form, it defines movement and determines future action. *Indian with Crucifix* is a somber work because of the subject matter and the lack of use of the background which, if filled in, would have determined whether the drawing was subjective or objective. As it is, the work remains a sad but delightful drawing.

John Young-Hunter was born in 1874 and died in 1955.

Elijah Pierce

In most cases Primitive painters do not acknowledge visual perspectives or the advancement and recession of color. They frequently ignore the foreground and background areas in favor of a frontal plane. The working surface is flat and remains flat. Three-dimensional characteristics are seldom evident. And so it is with Elijah Pierce's painting titled *Crucifixion*, 1936. The ingredients of the crucifixion site are all present — the crucified Christ and two criminals, the Roman soldier piercing Christ's side, the devil with his pitchfork, the crying women, the roll of the dice and other mourners and audience members.

Pierce's portrayal is unique. In spite of a hundred or more figures and objects, the artist chooses not to resort to overlapping. This separation is sometimes necessary in a painting in order to make known all elements of the expression. Pierce's work relates no awareness of a traditional composition. He simply painted one figure adjacent to another, but never overlapped them. The result is a depiction in which space exists between each element, allowing the viewer to acknowledge each figure and object in its completeness. Although the image of the crucified Christ occupies a central position, he is afforded only a slight advantage in recognition. The figure itself is flat. Elbows are nonexistent as straight diagonals from shoulders to hands define the arms. It is difficult to tell the mourners from the sinners because bodily gestures appear to be the same.

Pierce's *Crucifixion* resembles a decorative object not unlike a wall hanging or carpet. Although there are decorative paintings, it seems that Pierce's image

Opposite: Crucifixion by Elijah Pierce (1936). Carved and painted wood, heightened with glitter. 47½ × 30½ in. Columbus Museum of Art, Ohio: Museum Purchase.

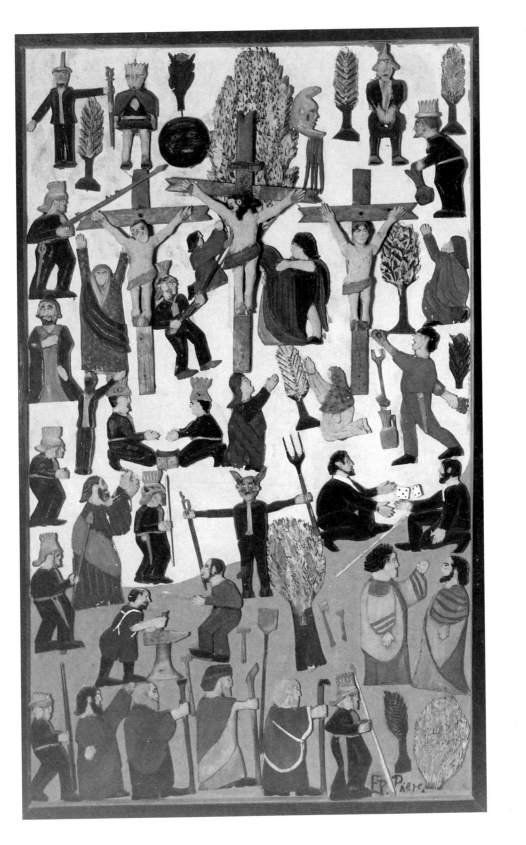

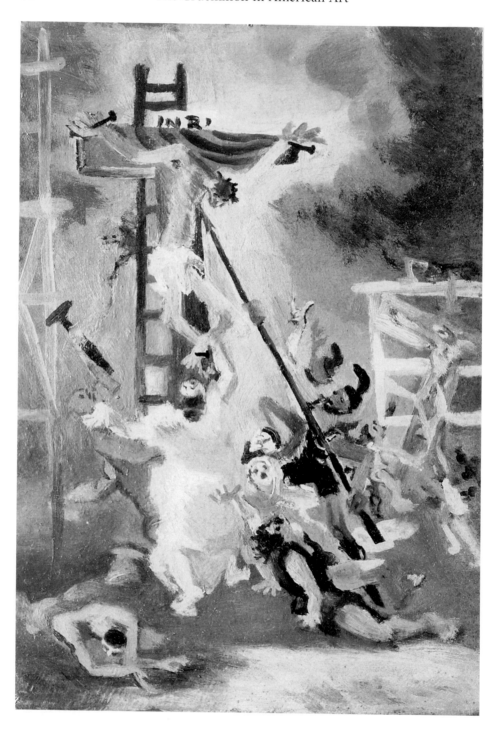

The Crucifixion by Franklin Watkins (1931). Oil on canvas. Whitney Museum of American Art, New York, N.Y.; Purchase, 31.373.

of Christ and the occupants is a deliberate attempt to portray the tragic scene itself and includes all figures that he felt necessary to involve.

Regardless of the repetition of design, all human forms appear as if anchored in space. The attempts at bodily movements fall short since the attempted action appears complete or has not yet started. *Crucifixion* is overflowing with symbols, not always readily recognized. That is the nature of Pierce's expression.

Franklin Watkins

Franklin Watkins is noted for several versions of the Crucifixion. Simply titled *The Crucifixion*, this 1931 version represents a drastic change in composition and technical application of pigment. The profoundly dramatic approach differs considerably from another *Crucifixion* Watkins painted in 1964.

This earlier painting reeks of savagery. The image of Christ is created like a tortured animal, and the grotesque flamboyance arises from the intuitive process of pigment application. Human figures are blurry in appearance, but the intentions of the evildoers are difficult to dismiss. The faithful humbly genuflect before the tortured figure of Christ whose flesh is torn from his body.

This is a scene of frenzy, a scene totally out of control. The physical features of the crucified Christ are ugly indeed. The performers take pleasure in mutilating his body.

There is a second crucifixion seemingly unnoticed but tucked away in the far right of the painting.

In this scene of action, Watkins seems to be telling us that we are responsible for Christ's suffering by our sins, and perhaps he felt that exaggeration and distortion were the best means of making us aware of our sins.

A sense of madness pervades the entire painting, as if the world has gone berserk. Compositionally, Watkins has used several verticals throughout, and with appropriate diagonals, has produced a total and complete composition in spite of the mania activated on the canvas.

Watkins' work is exaggerated realism that places him among the finest American religious artists. Most of his paintings are raucous, including those with secular themes such as *Fire Eater*. And yet there was a certain charm in his work, having to do with composition.

Franklin Watkins painted several versions of the Crucifixion. However, two versions in particular executed in the intuitive style varied only in the positioning of the characters even though the action was identical. Both were executed in 1931. Each is an event of extreme brutality. It is explosive as each character, whether mourner or executioner, appears lost in a frenzied attack, not only on the crucified Christ but in the scrambling to position himself for the attempt to lower Christ from the cross.

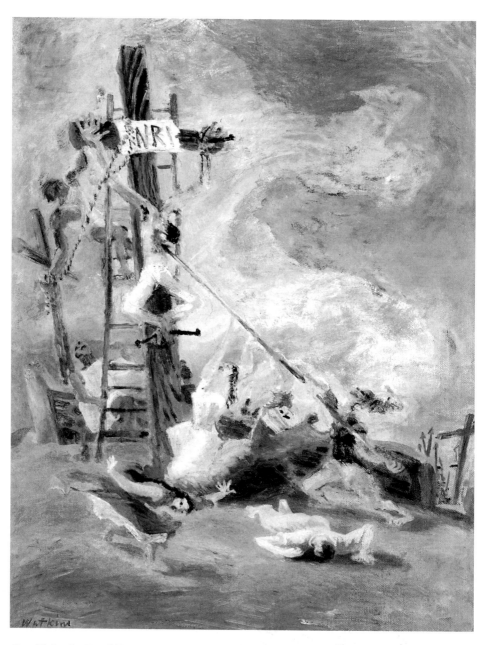

Crucifixion by Franklin Watkins (1931). Oil on canvas. 28⅛ × 22¹⁄₁₆ in. Courtesy of the Pennsylvania Academy of the Fine Arts, Philadelphia, Pa. Gift of Harry G. Sundheim, Jr.

In the second *Crucifixion* of 1931, the visual perspective lacks great depth, and all activity is executed on a frontal plane. The land, sky, and figures are painted in an intuitive style; lacking, however, is the Abstractionist Expressionist technique. Some figures overlap in sharp contrast, while others blend or blur into one another.

The crucified Christ is extremely distorted, reflecting intense agony. Watkins' seemingly erratic attack upon the figure of Christ appears to be an illustration of

the sins of society. Numerous body parts are not defined, but rather quickly applied, wide swishes of pigment identify the several segments of the human bodies. Figures are slashing brushstrokes; they do more than define human anatomy, and reveal the degree of suffering incurred in the mad scramble to release Christ from the cross. Even the mourners traditionally pictured in motionless postures are restless and eager to aid each other but in so doing frequently cause confusion.

A second crucifixion is witnessed at the extreme right of the canvas. The crucified criminal is suggested by slashes of color with the omission of physical features, especially the face.

Watkins has created a scene of continual action. Although stilled on a motionless working surface, the characters continue to struggle to free the crucified Christ.

Paul Cadmus

Paul Cadmus was a wizard at anatomical expression. Every segment of human anatomy is accurately expressed and deeply felt. His depiction of Christ having been lowered from the cross illustrates an array of different poses and movements. Each figure is not only an important part of his composition, but exhibits an emotional reaction to the deceased Christ.

Deposition is an intimate view of the death of a victim as exhibited by the group of agonizing women. The painting is both objective and subjective. The nearness of the suffering mourners reveals detail that might otherwise go unnoticed. The figures form a unit. Even though each is treated individually, which makes for an objective expression, the group as a whole takes on a personal and subjective form. Each of the five humans, by bodily and facial gestures, provokes the viewer into a state of helplessness and hopelessness. In spite of the occupied foreground, Cadmus promotes an important recognition of the background. A crucified form clings to a cross while a figure frantically appeals for mercy. One is not quite sure whether the form is Christ before his descent from the cross or whether the body is one of the two crucified criminals. A second figure is groping for assistance after being overwhelmed by the awesome nature of the event.

Cadmus' concern for the background was overshadowed by the figure of Christ, but nonetheless, he utilized it to match the fervor of the foreground experience. His light is marvelously distributed throughout the painting and contributes to the three-dimensional appearance of the characters. In a sense, *Deposition* is a traditional portrayal and not unlike those of the painters of the Renaissance period. It could well be a detail of a larger work.

Paul Cadmus was born in 1904 and died in 1999. *Deposition*, his only religious painting, was influenced by his travels in Spain. It was painted in 1932. Even

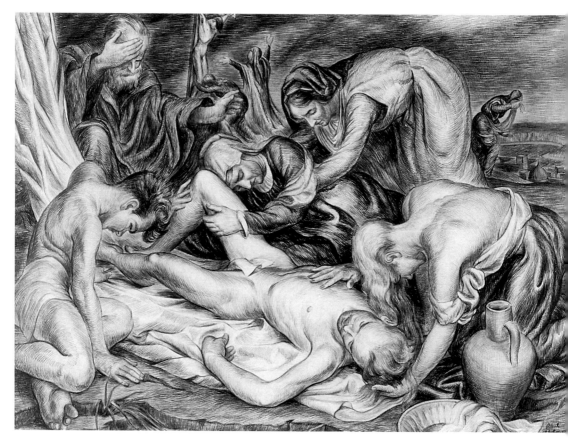

Deposition by Paul Cadmus (1932). Watercolor on heavy, handmade wove paper. 24¹³⁄₁₆ × 34¹⁵⁄₁₆ in. Hood Museum of Art, Dartmouth College, Hanover, New Hampshire; gift of Ilse Bischoff.

though the mourners appear to be weeping, exhaustion also is evident. Paul Cadmus was never noted as a religious painter, but *Deposition* is a provocative and remarkable work.

William H. Johnson

William H. Johnson was one of the finest American Primitive artists of the 20th century. His circa 1944 painting *Mount Calvary* is dynamic in spite of its simplicity. Christ occupies the central position surrounded by the crucified victims at his side and the three Marys. The mourners are not crying but express signs of resignation. Facial features are sad and motionless. All figures but the two crucified criminals wear halos. The two thieves are black-skinned while Christ is pictured in a color tone of gray.

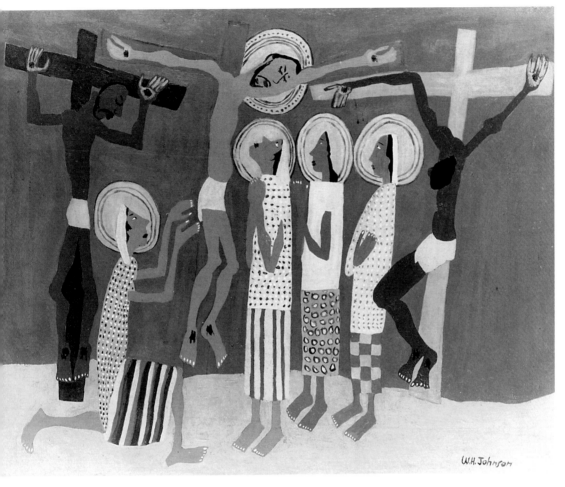

Mount Calvary by William H. Johnson (c. 1944). Oil on paperboard. 27¾ × 33⅜ in. Smithsonian American Art Museum, Washington, D.C., Gift of the Harmon Foundation.

All figures are distorted; this is not a deliberate form of exaggeration but one of a natural flow, an innate quality which is characteristic of Primitive Art. Johnson was not concerned with correct anatomy, but with the message of the event. Arms and legs of all figures are mangled out of shape as if the three crosses were erected and the figures forcibly fitted to the geometric shapes. In spite of the simplicity of dress, Johnson insisted upon applying intricate designs on each of the women's attire. Perhaps without his realizing it, each piece of clothing appears old-fashioned, but each is applied in a careful and diligent manner.

The halo is of special interest. Each of the Marys' halos is identical in design and differs from that of Christ, whose halo's outer circle is lined with decorated dots of color. The three crosses are crudely composed; they resemble structures made of two-by-four lumber. Johnson has omitted a usual trait of primitive art, the baseline. Instead he has raised the foreground to indicate a three-dimensional

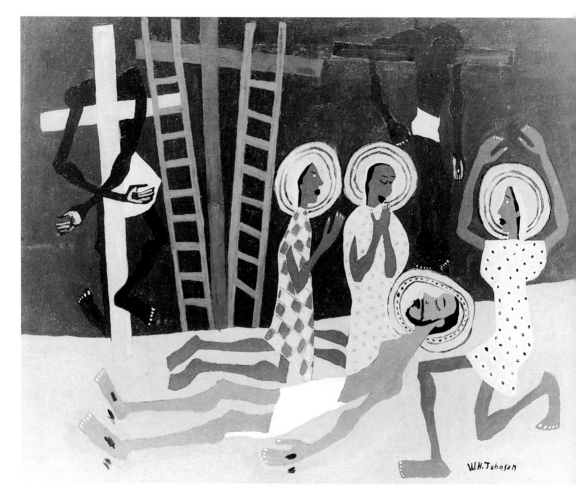

Lamentation by William H. Johnson (1944). Oil on canvas. Smithsonian American Art Museum, Gift of the Harmon Foundation.

quality. The darkened background not only forms a strong contrast with the decorative figures, but also coincides with the drama of the event. In spite of the terrifying incident depicted, *Mount Calvary* is a pleasant painting that one can appreciate for its honesty, directness and simplicity. William H. Johnson ranks high in the mainstream of American art.

To show that colors are paramount, Johnson in his 1944 painting *Lamentation* has painted each of the three crosses a different color by personal choice — yellow ochre, ultramarine blue, and violet. Even though it appears that color choice did not matter, it did; Johnson used color compositionally, structurally. Aside from the African skin color applied to Christ and the three Marys, pure colors dominate the scene. The background is dark so that the figures of Christ and the women dominate the foreground. To show the compositional approach he has used, Johnson has hoisted two ladders against the empty cross from which

Crucifixion Sketches by William H. Johnson (1944). Pen and ink, and pencil. 16¾ × 13¾ in. Smithsonian American Art Museum, Washington, D.C., Gift of the Harmon Foundation.

Christ has just been lowered. But the color of the ladders has nothing to do with the crucified Christ.

It would seem that *Lamentation* diminishes the importance of the execution of the two criminals. Their bodies blend into the dark environment, causing a need to discover that which is not immediately visible. Why would Johnson deal with the two criminals differently from Christ? The two thieves are pictured with arms embracing the back of the crosses. Spike dents and blood marks are revealed on the hands, which means they must have been nailed to the cross. Their feet dangle, suggesting that *they* were never nailed to the cross. Since these details do not apply to the title of the painting and the emphasis is on Christ, Johnson used these unusual facets for compositional purposes. Johnson has utilized both vertical and horizontal compositions on a rectangular surface. Both the foreground and the background, along with the position of Christ, form the horizontal composition, while the three crosses, ladders and three women form the vertical composition.

A careful duplication is applied to an insignificant element, that of fingernails and toenails. Because of the seeming unimportance of such elements, they actually become an exciting addition to the whole. Johnson was influenced by such masters as Van Gogh, Kokoschka, Gauguin, and Matisse and experimented in several art movements before settling at last into his sophisticated Primitivism.

The medium of drawing is perhaps the most immediate form of expression. Drawing, especially if linear or contour, will exhibit mistakes. In the case of William Johnson's 1944 series called *Crucifixion Sketches*, drawing errors are revealed in several of the combinations of possible poses. Johnson has experimented with a variety of compositions, to see which offers the most charming approach to a single image. The physical body of Christ is altered in the various poses. Since the drawing is a series of sketches, errors matter little because the artist's concern is more for interesting and diverse images — which might later be the basis of a painting — than for perfection.

A major repetition in Johnson's Crucifixion compositions is the inclusion of the figures of Mary. She is again present in the *Crucifixion Sketches*. The drawing is cumbersome and obvious, but the final drawing prior to the painting would have been without drawing mistakes. Since this is a series of sketches, there is no need for a visual plane or visual perspective. All figures seem to float in air. The halo, a symbol of holiness, is a natural addition. Johnson experimented freely with the head, revealing it in various poses. The position and slant of the head often determines the type of composition in works about the Crucifixion of Christ.

Each Christ figure exhibits a beard, which is most common. The lack of visual perspective is due to the need to crowd several versions onto a single working surface in overlapping images. The images of Christ are all slender in appearance, which denotes agility. The potential mobility of Johnson's subjects allows for a flexibility in the process of painting.

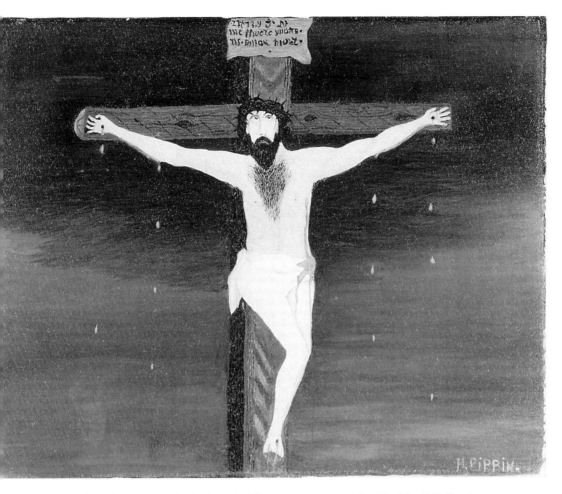

The Crucifixion by Horace Pippin (1943). Oil on canvas. 16 × 20 in. The Menil Collection, Houston, Texas.

This series of sketches was never meant to be a complete expression, but rather was a practice drawing prior to the final composition. Eventually, the completed and final drawing would have been transferred to the painting to act as the basis for the central and dominating subject.

Horace Pippin

Horace Pippin was of the Primitive school of art. In 1943, this self-taught artist painted a unique image of the crucified Christ. Titled *The Crucifixion*, it portrays a simplicity which is commonplace among Primitive works. The image of Christ is formally balanced in front of a mute but overcast sky area. There are

no mourners, sinners or Roman soldiers to share this sacred and historical event. Pippin's painting varies considerably from the works of other artists. For example, hair has become a prominent feature. It occupies a significant portion of Christ's body.

In spite of the intense agony, Christ's eyes are open and gazing heavenward while his head remains upright. Unlike other crucifixion paintings, blood flows from Christ's left side instead of the right where a Roman soldier pierced him with a spear.

Christ's feet overlap and are nailed with a single spike, creating a distorted figure. Blood exudes from the hands, feet and side, and the body is free of the often-seen scourge marks from which blood flows. A noteworthy image is the delicate drops of blood dripping from his hands and elbows. The count of blood drops is seven from the left side and six from the right. This minimal number suggests a bloody portrayal without excess. It may also suggest that death is near, that Christ's body has all but been drained of blood. A crown of thorns is barely noticeable piercing the forehead.

Pippin has recorded his message in an effective manner, simply, humbly and directly. *The Crucifixion* is a subjective expression, an intimate, personal reaction to the event. It lacks figures and objects which would otherwise interfere with an immediate response to the painting. The cross blends slightly with the background, giving Christ the appearance of floating in the atmosphere. Again, Pippin's purpose was to allow the crucified Christ to be the focal point of the painting.

Jon Naberezny

Jon Naberezny's simply titled *Crucifixion* is a 1943 painting executed in the Abstract Expressionist style. Christ is centrally located, flanked by three other figures, one of which is pointing a finger at the crucified Christ, which may hold various meanings and interpretations. Naberezny's painting presents a powerful message. The agony is reflected in the technical use of his medium, and whatever scars exist are hidden in the artist's use of his brush and palette.

Extreme distortion lies within the figure of Christ, distortion which does not reveal the spikes driven into the hands and feet of the crucified. Piercing thorns crown the head and brow, and his head is lowered, suggesting the final hour. The use of strong contrasts and the semi-abstract approach make for a successful application of the interpenetration theory.

Naberezny's painting, executed during the middle forties when the Abstract Expressionist movement was a strong motivation in American art, became an inspiration for several artists shortly after World War II. The distribution of darks and lights, combined with strong contrasts and the interplay throughout the

Crucifixion by Jon Naberezny (1943). Oil on canvas. 41 × 48 in. Courtesy of the Butler Institute of American Art, Youngstown, Ohio.

painting, creates a three-dimensional appearance upon a two-dimensional surface.

Horizontal and vertical planes underlie the figurative forms and, combined with a few rest areas, allow the viewer to search for unforeseen factors. The use of advancing and receding figures is rejected in favor of a strong unit of four figures arranged in a rectangular composition. Shadows are employed where they serve a dramatic purpose. This technique was used extensively throughout the painting. The painting allows room for speculation as to the personal feelings of the artist, while producing a source of contemplation.

Joseph Hirsch

The Crucifixion by Joseph Hirsch (1945). Colored lithograph on paper. 21 in. diameter. Courtesy of the Butler Institute of American Art, Youngstown, Ohio.

Joseph Hirsch's version of the Crucifixion focuses on the figure responsible for nailing Christ to the cross. The left arm of Christ is the only visible segment of his body revealed in Hirsch's 1945 work, which is simply titled *The Crucifixion*. The circular portrayal is marvelously composed of heavy ropes which are strung around the cross and the left arm of the victim. The combination of the linear ropes and the broad crossbar of the cross forms a forceful contrast. Centrally located is the figure in the process of preparing Christ for his death.

There are no signs of suffering and agony since the image of Christ is all but ignored. Since the front view is absent, there are no signs of bloodshed. Hirsch was noted for his realist portrayals during the 1930s and 1940s which dealt with various commonplace subjects. *The Crucifixion* is unusual because of the subject matter. He has executed a composition unlike any other artist dealing with this religious event. Because the image of Christ is all but excluded from the painting, this approach becomes a significant one because it demands of the viewer a search for the vital image of Christ. Because of this, Hirsch's version may be classified as intellectual rather than emotional.

The Crucifixion reflects a grotesque activity treated as an ordinary task. What is there to be excited about? Christ is not even pictured, except of course for his left arm that is partially hidden by the broad crossbar. The inclusion of the upper part of the ladder is subtle but essential to reveal the height of the cross. Hirsch was held in esteem for the various contributions he made to American art during his illustrious career. *The Crucifixion* is one such contribution.

Rico LeBrun

Rico LeBrun is noted for his paintings of the Passion of Christ, especially the Crucifixion. In his *Study for the Crucifixion* (1945, not pictured), LeBrun presents a powerful image. It possesses hints of Grünewald and Sutherland. The strong muscular torso dominates the central portion of the canvas and is flanked by strongly contrasted figures on each side of the crucified Christ. Particular aspects of Christ's body are suggested rather than defined. In spite of the powerful images there is a perfect blending of abstract forms. A profound sense of interpenetration is experienced as a tortured body is revealed in hunks of flesh that are translated onto canvas in a unique blend of subtle and sharp contrasts.

The figures adjoining the image of Christ are abstract and merge into the darkened and gloomy environment. LeBrun's painting is not easily addressed. His message is wonderfully expressed without losing the agony of the Crucifixion. The adjacent figures are partially clothed without losing the anatomical strength which lies underneath.

The power which exudes from *Study for the Crucifixion,* as in all of his religious works, stems from a thorough knowledge of anatomy and the holding of that knowledge until the intuitive process is prepared for execution. The image of Christ's body is a strong combination of bone, flesh and muscle, but distorted to create an emotional reaction. Even in the darkness of his background, there lurks an unidentified figure in the lower right corner of the canvas. Contour lines and gestures are positioned in the appropriate areas to strengthen the composition as well as the message of the artist.

Zelda Sayre Fitzgerald

Cascading down in a pyramid shape, figures with eyes closed and heads upturned tumble lifelessly from the large cross which divides the painting. The figures fall into a field of red poppies. The topmost Christ figures in Fitzgerald's 1945 painting titled *Deposition* are still on the cross, with successive figures showing His descent. On the right of the large cross is another smaller cross left unattended. Soldiers and mourners surround the Christ figures.

The head of Christ is seen slightly below the crossbar, and the rest of His body becomes tangled up with the several other bodies that, in theory, are attempting to motivate the deposition. To identify the entire body of Christ is impossible because of the interpenetration of the several mourners and spectators. The mourners appear in the forefront of the canvas. The entire painting is a jungle of human segments which cannot be separated into single individuals.

Deposition is a form of Abstract Expressionism except for the well-conceived

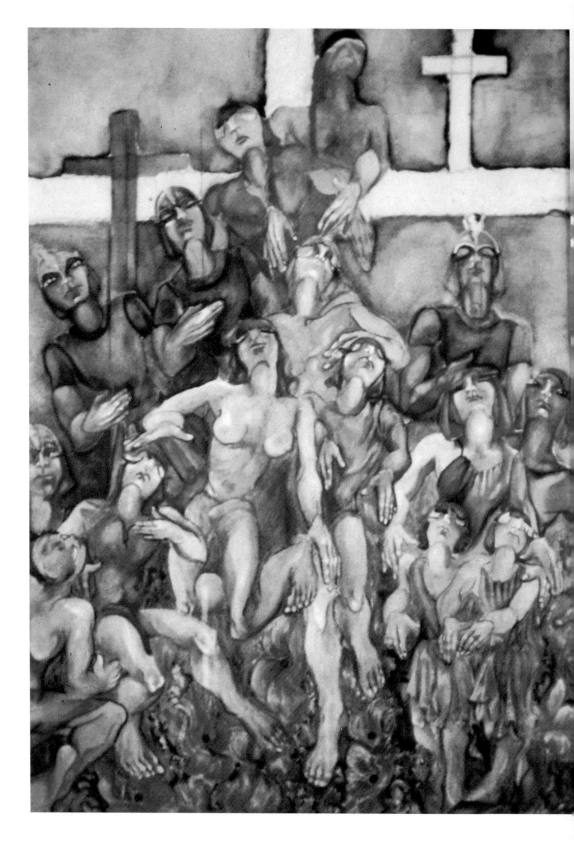

plan of composition, but the final expression appears neatly confusing. All figures seem anchored to the foreground, leaving the background somewhat free of activity except for the smoke-filled sky similar to that of a battlefield. The entire painting is intensified by the grotesque facial expressions and the seemingly overlapping figures which deny one another full grasp of the event. Physical details are particularly pronounced in the hands and feet of the mourners.

Deposition, a watercolor, is typical of the painting of the 20th century. The two world wars influenced the art of the period, including Fitzgerald's, filling it with disturbing images. In Fitzgerald's case, though, the disturbing images may have come as much from within as from without. For the last 18 years of her life, she battled schizophrenia and ultimately died in an Asheville, North Carolina, mental hospital in 1948 at the age of 48. A fire in the asylum, however, not natural causes, claimed her life.

Zelda Sayre Fitzgerald had been married to the writer F. Scott Fitzgerald (1896–1940).

Romare Bearden

Romare Bearden painted *Golgotha* during the year 1945. His watercolor painting on charcoal paper is a superb example of the gesture technique. With a few lines he has expressed with great emotion the agony of the crucified Christ. Because gesture drawing is more suggestive than definite, the details of Bearden's Crucifixion are omitted, and the elements or images are extremely distorted. Exaggeration of physical features is directly associated with the human parts which are the source of agony. For example, Christ's head is huge compared to the tiny feet. Nails piercing his hands are elongated beyond their natural length.

The three Marys surround the crucified Christ, each sustaining a devout countenance. Again, particular features are distorted beyond recognition. Suggestion is offered instead of definition. Gesture drawings resemble scribbles, not in the sense of doodling, but in a personal and timely expression representing a definite element in the painting. Romare Bearden has used this method to quickly express his intimate response to the subject matter at hand. It is an entirely intuitive process. What appears as an error or sloppy drawing is really a true statement, and once expressed, cannot change.

There is a definite beauty in the intuitive act if expressed as a lofty idea. Bearden's Crucifixion or *Golgotha* may appear ugly to some viewers and compassionate to others. Bearden has included straight and circular lines in areas

Opposite: Deposition **by Zelda Sayre Fitzgerald (1945). Watercolor. Montgomery Museum of Fine Arts, Montgomery, Alabama. Gift of Mrs. Frances Fitzgerald Smith.**

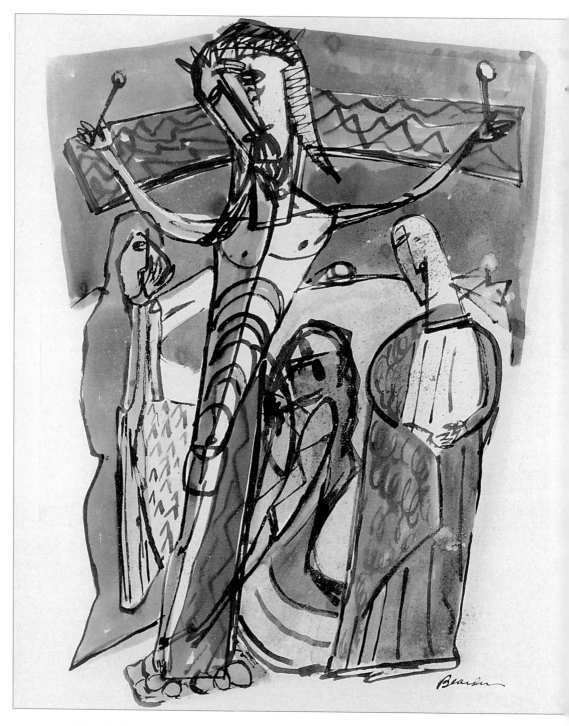

Golgotha by Romare Bearden (1945). Watercolor. 26 × 20 in. Smithsonian American Art Museum, Washington, D.C., Gift of International Business Machines Corporation, ©Estate of Romare Bearden.

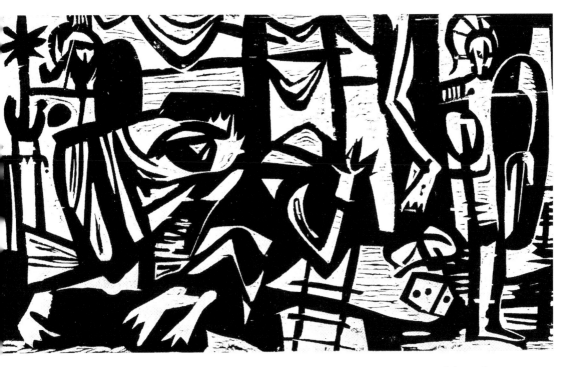

The Final Agony by Walter Feldman (1952). Woodcut. 18½ × 32½ in. Courtesy of the artist and Brown University Department of Visual Art, Providence, R.I.

throughout the composition in a way that creates compatibility amid the differently shaped images such as the subject matter.

One must realize that the notion of the crucifixion that Bearden created is just that—the image, the description Bearden himself had in mind at the time. It is an image that could never have been repeated identically; those that might have come after could not have been the same as this original expression. This sense of uniqueness about *Golgotha* is one of its great charms.

Walter Feldman

Walter Feldman's *The Final Agony*, 1952, is an abstract expression in which symbolic images overlap one another. Feldman has not revealed the crucified Christ except for the lower torso, so the viewer is not confronted with the anguish and agony of Christ. The scene focuses on the foreground or base of the cross. Two crosses minus the two criminals appear in the central portion of the wood-cut. Mourners are positioned at the base of the cross upon which Christ was crucified. *The Final Agony* is not a traditional image of the theme. Rather, it is a combination of symbolic images placed in appropriate areas throughout the

composition: the ladder leaning against the cross, the dice rolled for Christ's garments, a Roman soldier, and the cock that crowed marking Peter's three denials of Jesus.

In spite of its complexity, *The Final Agony* is a complete and total composition easily acknowledged as such. It becomes a visual journey. The beauty of an abstraction is the opportunity of visually flowing in and out of the composition. There is no background, middle ground or foreground as one would have in visual perspective. And yet, in spite of its apparent flatness, there is a sense of the presence of the three planes one would also have in a representation with visual perspective. The uniformity of the expression is due to a similar importance being granted to each symbolic image. The distribution of dark and light areas maintains the compositional flow of visual acceptance. Each fragment of a dark color is complemented by a similar light-colored shape. Negative and positive shapes equally share the images that constitute the composition. A negative area creates a positive area by the appropriate placement. Feldman manipulated all positive aspects so that the resulting negative areas join the initial positive area and form a oneness. In other words, there is no separation, regardless of the apparent evidence to the contrary. In spite of its complexity, *The Final Agony* should be casually viewed. It is not a shocker, but all elements of shock are present.

Siegfried Reinhardt

A tremendously powerful expression is witnessed in Reinhardt's painting. The culmination of torture and agony is evident in the physical being of Christ. The hands of Christ grip life in eternal strength as if to say the end is soon to come, but the beginning will never end. Reinhardt's strong abstract pattern incorporates a lifetime of emotions.

Crucifixion, 1953, is a combination of distorted Realism and Abstraction, the strength of which is the strength of Christ. The hands of Christ are muscular and seem to grip the spikes instead of surrendering to them. His bowed head is pictured in shadow, and his ribs are a sign of strength and good physical condition. The thorns not only pierce his head but dominate the painting as if to remind the viewer that he or she too wears a crown of thorns. The triangular shape of the thorns inhabits the background environment thus sustaining compositional unity.

Christ's eyes are partially closed and hidden in shadow and yet all elements are prominently exposed. The human figure stationed alongside the crucified Christ is also in shadow. The entire painting seems to rely on shadows and highlights, and the distribution of each accounts for the unified composition. Although abstract, this painting is extremely detailed. Sorrow is reflected on the facial

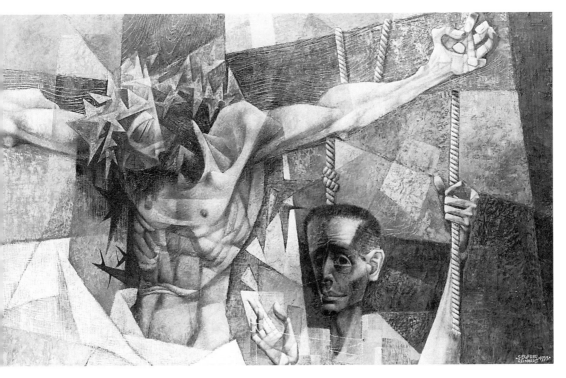

Crucifixion by Siegfried Reinhardt (1953). Oil on composition board. 28 × 45½ in. Whitney Museum of American Art, New York, N.Y.; Gift of William Benton.

makeup of the adjoining figure. The agony reflected in the painting is tempered somewhat by shadows which seem to lessen the degree of suffering. The triangular shapes which prevail throughout carry a note of mysticism. There is also a Cubist inclusion which is allied with the otherwise abstract forms.

The major factor that might engender compassionate concern in the viewer is the power that seems so well contained but nonetheless ready to produce an immediate emotional and profound religious experience. *Crucifixion* is a strong and agonizing portrayal which one can view religiously while appreciating its compositional unity.

Abraham Rattner

Perhaps the most prolific of the 20th century American painters of religious themes, particularly the Crucifixion, is Abraham Rattner. Although he was Jewish, Rattner roamed both the Old and New testaments for his ideas. He focused on men like Job, Abraham and Moses of the Old Testament, and Christ of the New Testament.

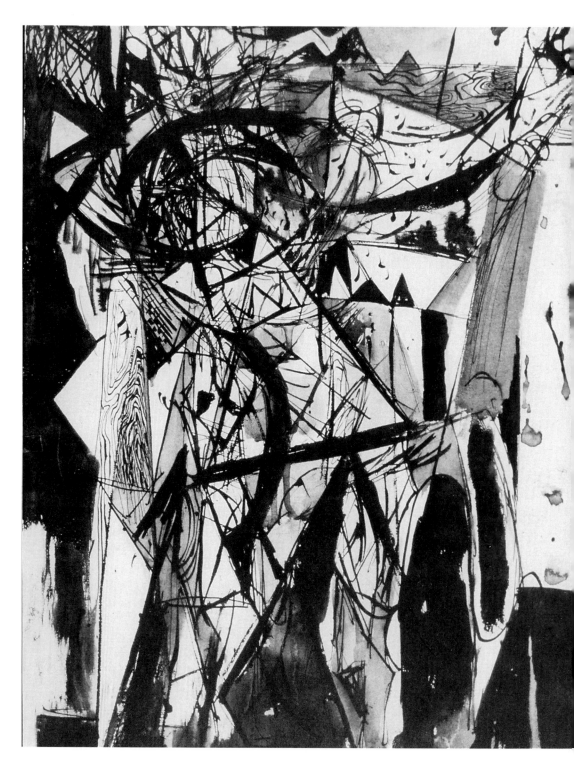

Crucifixion from the Portfolio of Abraham Rattner by Abraham Rattner (1953). 16¾ × 12¾ in. Leepa-Rattner Museum of Art, St. Petersburg College, Tarpon Springs Campus, St. Petersburg, Fla.

Although his *Crucifixion from the Portfolio of Abraham Rattner*, 1953, reveals images of Abstract Expressionism, Surrealism, abstract and Cubistic art, it still sustains an element of the intuitive process. Because of the overlapping and inter-penetration of the various styles, the overall look appears to be Abstract Expres-sionism. Rattner has included several of his familiar gestures and symbols, his sweeping dark lines to suggest the contours of figures and objects, and the short, jerky lines to fill in the inner stuffing of flesh. It is somewhat of a puzzle in which a search for familiar images is necessary. However, if such a discovery is made, then one questions its purpose in the painting.

The intuitive process is frequently overplayed and consequently becomes an exercise in musical rhythm. Rattner believed that the working surface (canvas) should be totally accessible for a total expression of his idea. This paint-ing consumes all space so that the entire painting is the foreground since the environment is diminished. And yet, one must admit that the empty canvas (before the paint is applied) was the background, but was demolished by the inclusion of an image that eliminated any outward space which appeared insig-nificant.

Rattner has succeeded in securing a oneness in *Crucifixion from the Portfo-lio of Abraham Rattner*. With the consistent overlapping and interpenetration, all images are connected and blended so that one is forced to view the whole and not segment after segment. Abstract Expressionism is an intuitive process which has at the outset an undefined goal. The creation process is stopped when Rat-tner senses its completion. The process can be underplayed or overplayed. The process itself becomes exciting because the ending remains unknown until the final brushstroke. Frequently, the time of completion does not arrive until months after the beginning, at which time the painting is considered a failure or success. Such a determination of worth is made by the artist alone.

Abraham Rattner's painting *Two Figures* is expressed in nuances of blue, the color alone suggesting the tragic event. Christ's mangled body is not unlike the revolting apparition in Grünewald's famous altarpiece. Made up of cubistic blocks of flesh, Christ's head is bent forward as if the final hour had arrived.

The background is blended-in tones of blue while the two figures are intu-itively applied blotches of flesh tones. Christ's shoulders are partially covered by the crossbar of the cross. The second figure (the artist himself) presents a provocative sense of shame, while his hands hold a palette in a forward gesture as if in prayer and while his head is focused upon the tortured body of Christ. The hands of the crucified Christ are difficult to discover amid the rocky forma-tion of the arms and hands.

Throughout his life, Rattner was seeking to join together the Old and New testaments in a oneness. He always painted the sad, downtrodden, the lost and bewildered. His own life was a tortured one. Each day was a struggle to perform as God would have him do. Rattner's *Two Figures (Deux Personnages), No. 1903*, is difficult to resist. One is forced to acknowledge his work and after doing so, one either accepts or rejects it. If one rejects it, one is guilty of a transgression.

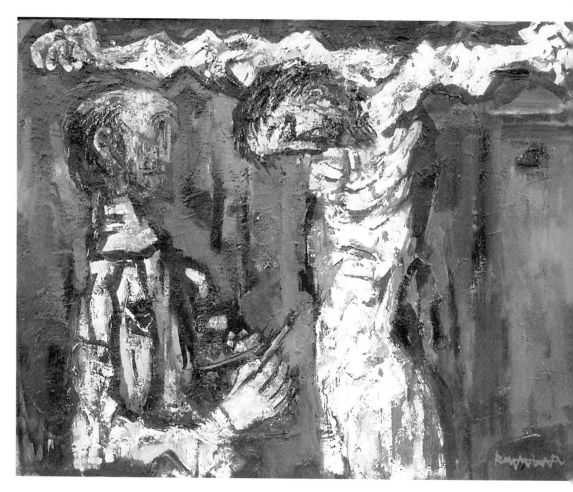

Two Figures (Deux Personnages), No. 1903 by Abraham Rattner (1964). Oil on canvas. 33 × 45¾ in. Leepa-Rattner Museum of Art, St. Petersburg College, Tarpon Springs Campus, St. Petersburg, Fla.

The partially remote figures are focal points that the viewer must consider in his decision. *Two Figures* is a 1964 production, painted during the hippie movement which was at its full strength during the Vietnam War.

Intuitive painting is provocative. It is an expression of an event or gesture at a given moment. Abraham Rattner was a master of Abstract Expressionism as well as the Cubistic and the Surreal. *Crucifixion No. 1920* focuses entirely and completely on the crucified Christ. The 1964 drawing is a vertical mass of muscle seemingly strewn about but which in actuality blends in harmony with a darkened background. Large, thick blotches of color are intuitively employed to shape a preconceived idea of the crucified Christ. Although chunks of flesh color form the crucified Christ, they do not appear offensive because of the completeness of the whole and its total togetherness. Here is a oneness that frequently eluded Rattner, who searched for a peaceful world his entire life. *Crucifixion No. 1920* is

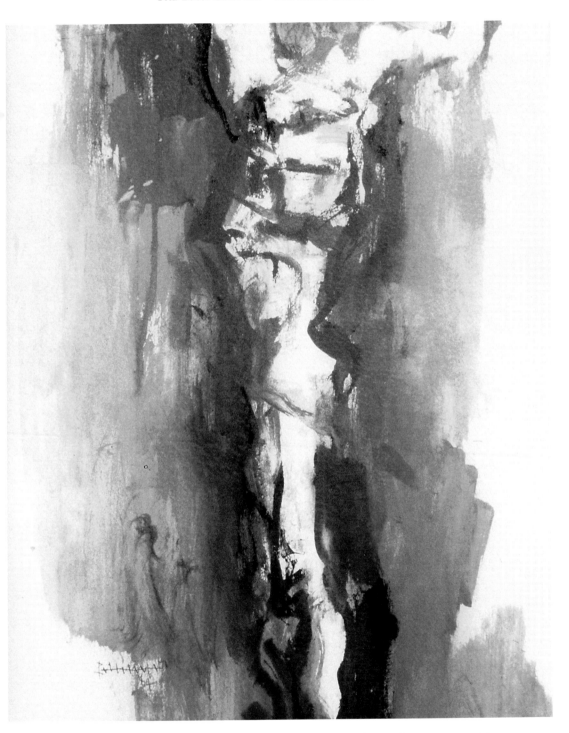

Crucifixion No. 1920 by Abraham Rattner (1964). Pen, ink and gouache on paper. 35½ × 23⅝ in. Leepa-Rattner Museum of Art, St. Petersburg College, Tarpon Springs Campus, St. Petersburg, Fla.

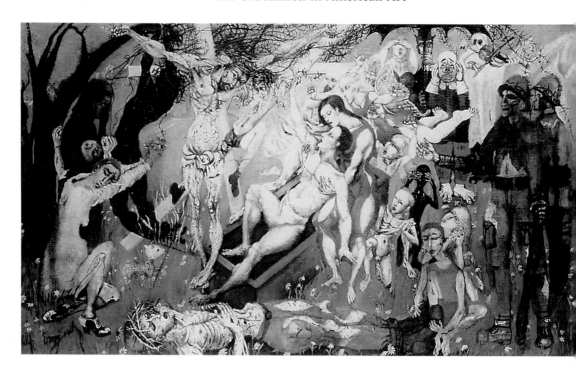

The New Lazarus by Philip Evergood (1927–1954). Oil on plywood. 48 × 83¼ in. Whitney Museum of American Art, New York, N.Y. Gift of Joseph M. Hirshhorn.

an example of oneness perhaps because his focus is on a single figure. Body features are difficult to discern because of the intuitive process.

The background is perfect in *Crucifixion No. 1920*. The contrast between the shaded darkened area adjacent to the crucified Christ and the lightened area that surrounds the darkened area, and reaches the outer limits of the canvas, makes for a simple, almost formal, composition. Rattner had the distinct quality of insisting on a complete drawing or painting. Such works appear unfinished, but given time, the viewer may become pleasantly surprised when a oneness finally emerges.

Crucifixion No. 1920 is somewhat pleasant to look upon in spite of the mutilated body. However, in time one no longer dwells on the subject matter but on the painting as a painting. Abraham Rattner's works will become historical icons, as he is one of America's finest dramatic artists dealing with the wrongs of society.

Philip Evergood

Strongly influenced by the work of European Renaissance painter Mathias Grünewald, Philip Evergood's famous painting *The New Lazarus* is grotesque in

its physical appearance. The Grünewald influence applies to the structure of Christ's body, not to the composition of the painting. *The New Lazarus* focuses on at least seven complete compositions within the whole. Perhaps that is the reason for the extended time Evergood took to complete the painting (27 years, 1927–1954). *The New Lazarus* may well be named an objective *and* subjective work. The canvas is consumed with activity, with all focused upon the figure on the cross. It is objective in the sense that all figures and objects are in detail. Considered separately, each figure is objective, but considered as a whole and complete composition each figure or object, since all overlap and interpenetrate, must be rated as a highly personal and intuitive expression.

The viewer's vision flows from one group or activity to another, creating a oneness or single complete unit. A group of three clowns appears in the upper section of the painting; they prefer to have no part in the event. "See no evil, know no evil, and hear no evil" explains their ignorance of the Crucifixion. The death and rebirth are evident in the deceased form of Lazarus and the sprinkling of flowers emerging from the earth's surface. *The New Lazarus* depicts a long-term view, or full circle of life, if you will.

Barbed wire surrounds the activity, reminding one of the wartime devastation of Europe and the death of countless soldiers of all nations. Two German soldiers observe the event but seem indifferent and unconcerned. Mourners and spectators are articulately painted so that the smallest of items is carefully rendered. Evergood's display of the anatomical segments, such as the feet and hands, is particularly noteworthy.

Lawrence Salander

Lawrence Salander's 1960 painting *Crucifixion* is an unusual composition. A deliberate balance of images assists in the occupancy of the background. Without the images the environment would be desolate. Salander's painting has no joining of the foreground and background areas. It is as if the images are floating in space, specifically the body of Christ on the cross. The Ascension is a possible explanation of this. The cross is not anchored to a baseline, thus creating a sense of surrealism. Salander's images are deliberately positioned with equal emphasis on all images even though the crucified Christ dominates the painting both in location and the space it occupies. The image of Christ is styled in the Expressionistic manner, revealing a textural quality. However, that halo enveloping Christ's head is in a white color and flatly painted.

The figure of Christ on the cross was expressed within rigid limitations. Although Christ's body reveals a textured layer of flesh, his hands are lighter in color and reveal no signs of skin texture. They show no nail marks and are crudely drawn as if they belonged to another human being.

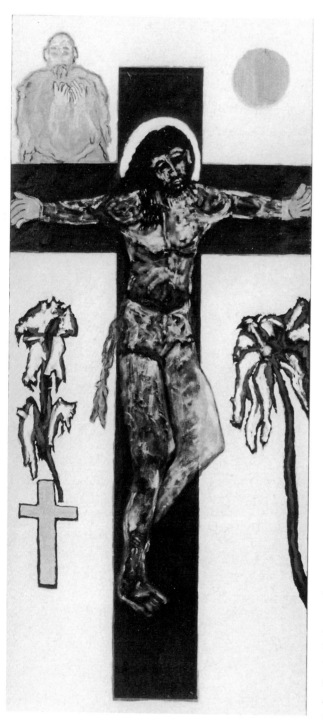

The rectangular shape of the cross has divided the painting into four segments which actually constitute the space remaining following the painting of the Crucifixion itself. One questions the addition of the images occupying these four areas and whether or not their removal would weaken or strengthen the composition.

Salander's *Crucifixion* is a combination of styles and media. There are elements of the Abstract, Surreal, Primitive and Realistic. Perhaps the exclusion of the four images surrounding the cross would have allowed for a more readily acceptable work depending on the artist's purpose in promoting them.

Mitchell Jamieson

Mitchell Jamieson's painting titled *Mediterranean: The Tadpole Pond Christ*, 1960, is Surrealistic in character. The entire background, except for a narrow strip of pebbles at the base of the painting, is made up of careful overlays of color which constitute the pond. The image of Christ is underwater, creating a blurry effect and diminishing his physical structure. In fact, the interpenetration of body and environment leans toward the Abstract. No marks of torture are evident on Christ's body. The contour of the body blends into the background, which accounts for the lack of identification.

Crucifixion by Lawrence Salander (1960). Oil on canvas. Smithsonian American Art Museum, Washington, D.C., Gift of Charles Simon.

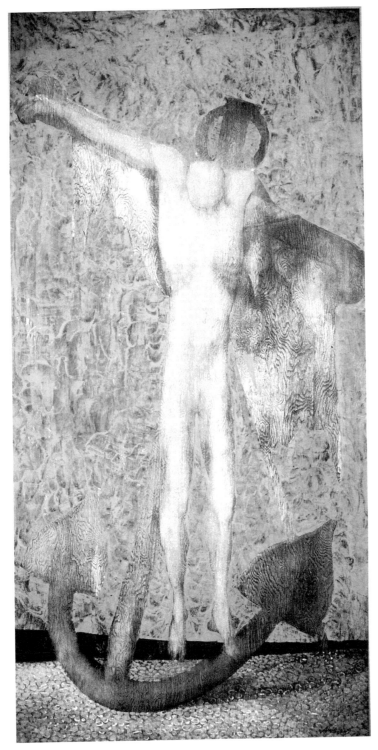

Mediterranean: The Tadpole Pond Christ by Mitchell Jamieson (c. 1960). Tempera on board. 48 × 24 in. The George Washington University Permanent Collection, Washington, D.C., courtesy of the University Art Gallery.

This unusual painting differs considerably in style from Jamieson's realistic works of the thirties and forties. The transparent body appears to be floating upward, although it is suggestively anchored to the base of the painting. The background is particularly subtle in its realism. Irregular designs covering the entire background are blended to form an all-over pattern. There are areas of grained wood painted adjacent to the body in an attempt to vary the textural background. The wood occupies a large area to avoid monotony.

Jamieson has used a smear technique which tones down the image and causes an atmosphere of mystery. *Mediterranean: The Tadpole Pond Christ* is an intimate approach to the theme of the Crucifixion. One can appreciate the variations of textures, the use of the gesture, and the general composition. Although surreal in context, intellectually the viewer needs to search in order to enjoy.

Clarence Carter

The Ninth Hour by Clarence Carter, 1960, is a dynamic use of negative space. The painting seems a study in composition because the subject matter is used in a positive manner. The entire background is treated quietly with a light cast harboring the base of the painting and gradually darkening upward. The unusual use of the crosses opposes the theory of advancement and recession of objects.

Segments of the three crucified forms are viewed from the rear, thus avoiding the presentation of agony and humiliation. No bloodshed, no piercing crown of thorns, no spikes nailed to the crosses add to the impersonal approach. The rigidly constructed design of the three crosses is accompanied by five spears arranged compositionally in vertical and diagonal planes. Without their presence, the composition would appear as three separate paintings or a triptych. It is a well-conceived composition in which positive and negative spaces are equally divided, not formally but informally enough to make the whole appear formally balanced.

The unusual approach reveals a symbolic use of a tragic event. The essential parts are all present, except for the mourners and soldiers which incidentally are unnecessary. There is quietness in the event and the outsiders are given no clue to the death of Christ and the two criminals. The three figures appear insignificant because of their partially hidden bodies. But because of this unusual approach, importance shifts to the three crucified figures even though the three crosses dominate the composition.

Opposite: The Ninth Hour by Clarence Holbrook Carter (1960). 55 × 32 in. Lafayette College Art Collection, Easton, Pa.

Crucifixion, II by Morris Broderson (1960). Textile paint, chalk, charcoal and ink on paper. 36 × 28 in. Whitney Museum of American Art, New York, N.Y.; Purchase.

This 1960 portrayal, although quite traditional compared to the contemporary work of today, is a break from Carter's usual Realistic display of the commonplace. Although simply composed, its approach is dramatic and proves the theory that the image of an idea can never be duplicated.

Morris Broderson

Crucifixion, II, 1960, by Morris Broderson reflects the Pietà, since Christ has already been lowered from the cross. In fact, the three crosses are not included in the painting. The combination of contour lines and a gesture background have created a quiet and subtle portrayal. The upper two thirds of the painting pictures three figures on horseback. Each figure carries a vertical object resembling a spear. The trio are extremely distorted as if little care was given to the natural structure of their anatomy. The single lines defining the contours of the figures are lines of an intuitive nature. Little concern is given to details. Facial features are distorted beyond reality, and fingers approach a resemblance to daggers.

In the lower section, Broderson has overlapped and intertwined the two Marys. A partial segment of Christ's body is shrouded in shadow, suggesting the finality of death. Even though death has already occurred, which would suggest a stillness, Broderson's technique of line and washes creates an active front plane by using the medium to form sharp contrasts throughout the painting.

The composition is well conceived and although reflective of the intuitive process of painting, its network of adjoining shapes lessens the degree of misunderstanding. Each shape flows smoothly throughout the painting, joining forces to create a complete and satisfying conclusion. Disturbing areas are daubed intuitively with tones of gray, a neutral color. Broderson was not recognized as an Abstract Expressionist, but *Crucifixion, II* comes close to identifying with that movement quite prevalent during the 1950s and 1960s.

Joseph Jeswald

Joseph Jeswald's collage titled *Betrayed Again* is not the crucifixion of Christ, but a symbolic crucifixion of mankind. In the place of the crucified Christ, Jeswald has painted onto a piece of weather-beaten wood images of human beings being victimized by the riots of the 1960s. Amid the myriad faces is a painted face representing Christ, executed in an unusual manner. Two large eyes are centered in the forehead of the painted image, which is topped with seemingly erratic brush strokes representing the crown of thorns.

Jeswald's 1962 collage is not an excuse. Instead of painting the traditional crucifixion, he painted the mortal beings whose lives and sacrifices were considered crucifixions of a different nature. The crossbar is consumed entirely by Christ's head and the vertical stem is laden with faces and skulls. So in a sense, although a total cross is evident, the lower torso is not represented. The face of Christ is partially hidden amid the numerous facial images and is not readily recognized as anything other than an abstract design.

Betrayed Again is intriguing because it is difficult to discover the image it represents and perhaps because the unknown makes for an exciting expression. In a sense, Jeswald's painting stems from the Abstract Expressionist movement, and the harsh brushwork more readily lends a three-dimensional aspect to the two-dimensional image. Finally, Jeswald's message is expressed on the least expensive working surface—old wood. If executed on conventional canvas, it would not have been as forceful.

Jonah Kinigstein

Christ Among the Clowns is a title and approach which has been used by several artists. The "Christ as clown" theory is frequently used because of its emotional content. In his *Christ Among the Clowns* from 1962, Jonah Kinigstein has positioned the image of Christ in the center of the canvas flanked by hideous creatures proclaimed as clowns. The terrifying expression on Christ's face not only creates horror in the viewer but declares a similarity between the clowns and Christ because the Christ image is intertwined with the ghastly ghost-like figures. It is difficult to react immediately to the ugliness of the Christ image because it blends so readily with the outlying areas.

The Abstract Expressionist movement was at its peak when *Christ Among the Clowns* was painted. Because of the unmatched intuitiveness of the process, the artist was able to express personal emotions more readily as well as amend errors by simply covering past intuitive expressions with more intimate and meaningful images. Although the painting possesses two major planes, the background and the foreground, neither claims dominance since the subject matter occupies the entire canvas. Christ's body is mutilated beyond recognition. Any scars or blood created by the persistent cruelty inflicted on Christ's body is hidden by the intuitive brushwork which has been applied within the physical image of Christ. However, the spiked hands must be viewed as areas of torture. A halo surrounds the head; although difficult to perceive, it does nonetheless proclaim Christ as divine.

Opposite: *Betrayed Again* by Joseph Jeswald (1962). Oil on wood. Courtesy of the artist, Joseph Jeswald.

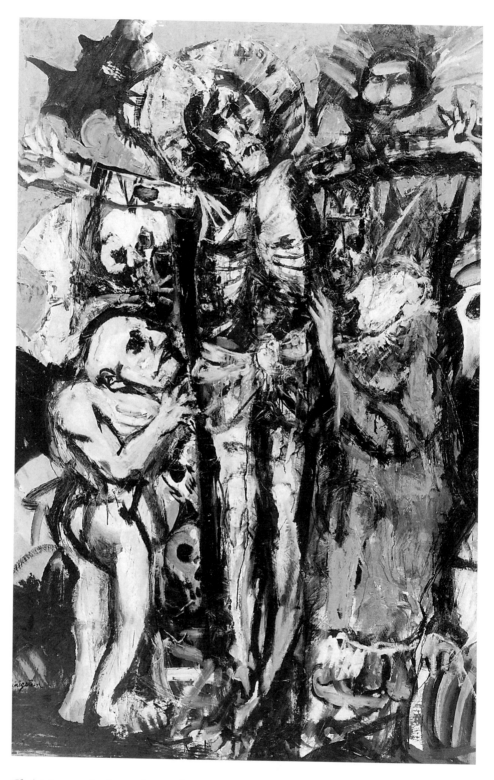

Christ Among the Clowns by Jonah Kinigstein (1962). Oil on fiberboard. 72 × 48 in. Smithsonian American Art Museum, Washington, D.C., Gift of S. C. Johnson & Son, Inc.

In a sense, Kinigstein's work reminds one of Grünewald's famous altarpiece which set the stage for vulgarity in the person of Christ during the European Renaissance.

Patrick Vaccaro

An unusual expression of the theme of the Crucifixion is seen in Patrick Vaccaro's 1963 *Crucified*. A three panel expression, extremely simple in composition, positions the figure of Christ in the central panel. The artist has expressed a symbolic portrayal with a few lines to the head, lower torso and halo. The entire serigraph is an extreme abstract work, not because of a complex execution of varying shapes and line forms, but because of its simplicity. The right and left panels are reversed in design. The image of Christ is not defined but instead a vertical geometric shape occupies space

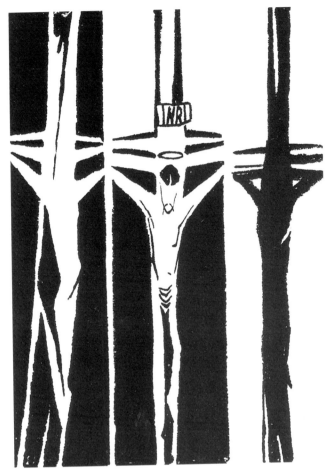

Crucified by Patrick Vaccaro (1963). Serigraph on paper 1/36. 10 × 14 in. Courtesy of the Butler Institute of American Art, Youngstown, Ohio.

adjacent to the cross. The two outer panels rely upon the middle panel for identification.

Vaccaro's serigraph does not emotionally involve the viewer. It is a simple pattern in which the three crucified figures are contained within its own boundaries. All the figures are evenly anchored to the base of the print. Only that of Christ is defined with the simplest of details while the two criminals are lessened in importance, because they are little more than geometric shapes without signs of identification. Although the three panels differ in composition, their figures are united in a single aspect of human nature. The three panels are essential for the success of the portrayal. The artist has utilized considerations of the background as a part of the whole. But in other aspects, attention was not given to the background, except in that a positive aspect has pierced the negative environment. This even holds true for the right panel. In fact all three panels were

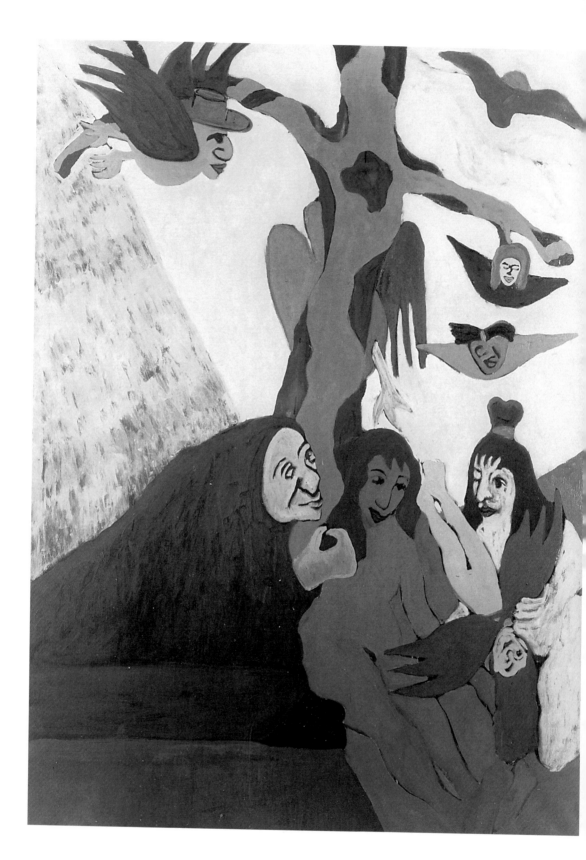

left unattended until the positive aspects split the background into varying shapes of emptiness. However, those shapes of emptiness became positive because they formed a single unit. For without the emptiness there would be no positive. The two opposites when occupying a single space become one. Vaccaro has used the basic elements of drawing to portray a single aspect of human nature and has not embellished the expression, which would only have defeated the original idea.

Bob Thompson

In Bob Thompson's 1963 painting titled *Descent from the Cross*, the word descent grants the viewer a peculiar opportunity to match the painting with the title. Although the shadow of the crucified Christ remains etched in the tree on which he was crucified, an initial glance does not discover Christ's body. Small in stature, his body rests in the arms of one of the Marys, but the emaciated body adds to the morbid mood of the painting. The figure of Christ is de-emphasized so that the discovery becomes a mysterious venture.

Facial angels appear in the backdrop as bats flying around the empty tree. Thompson's purpose in portraying Christ as a puny, infantile individual is either to indicate the sins of society or to express the painter's notion of Christ's intense suffering. One angel (bat) wears a derby hat, suggesting the theme is set in the 20th century. Another is a female, and a third is faceless. The three Marys are ghostly and morbid, causing one to wonder about them. There is little doubt that Thompson used scare tactics to indicate the physical and spiritual downfall caused by society itself.

In each face one witnesses an unreal image. The outstretched arms of the tree, which represent the horizontal member of the cross, unite two of the morbid angels. The backdrop has three triangular areas which serve as a compositional technique and as muted segments that indirectly create an appropriate environment. However, the inclusion of the flying creatures presents to the viewer a scene never to be forgotten.

The surreal atmosphere is not unlike the celebration of All Soul's Day, the honoring of the dead in purgatory. It is interesting to note that the crucified Christ is sidelined in favor of the compassionate Marys.

Opposite: Descent from the Cross by Bob Thompson (1963). Oil on canvas. 84 × 60⅛ in. Smithsonian American Art Museum, Washington, D.C., Gift of Mr. and Mrs. David K. Anderson, Martha Jackson Memorial Collection.

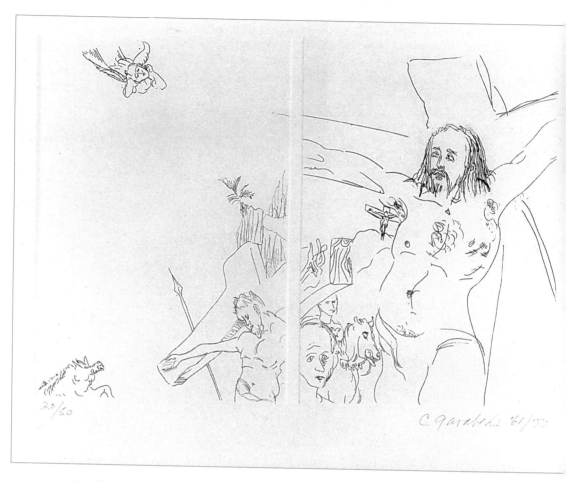

Crucifixion by Charles Garabedian (1961–80). Etching. Santa Barbara Museum of Arts, Gift of Stephen Acronico.

Charles Garabedian

Charles Garabedian's etching titled *Crucifixion*, 1961–1980, takes on a resemblance of an incomplete drawing. Using contour and gesture lines, he has successfully transferred an idea in the simplest of terms and still captured the essence of the Crucifixion. A few lines drawn in appropriate areas form the composition. As an etching, it appears more like a sketch for an altarpiece. The three crucified figures are positioned in unusual areas and in totally different manners.

Two panels constitute Garabedian's etching. Neither panel looks complete although the panel on the right fulfills much of the limited scope of the etching. The artist has omitted the hands and feet and thus no blood is shed. An area of the left panel is inserted into the right panel creating a bit of confusion since the projection forces one to acknowledge an alien object. The left panel also reveals a segment of that crucified form. The spear which punctured the side of Christ

is pictured in a diagonal technique that combines the outstretched arm of the victim, the right side of the crossbar and the pointed spear itself.

The etching appears to be an attempt to join together two unfinished areas into a whole. Because it is a line drawing, vast areas of emptiness compete with the three crucified victims. Incidentally, the third crucified victim resides under the armpit of the larger physical being which occupies the majority of space in the right panel. Disconnected images occupy both panels which allows space rather than the images to dominate the composition. But again, the use of contours and gestures in a double panel gives the appearance of two separate etchings, neither of which seems to be personal. However, as sketches for a painting or a large single panel etching, potential power reigns within. *Crucifixion* is indeed an unusual approach to the theme which demands recognition of the agonizing pain of the victims.

William Congdon

William Congdon was perhaps one of the few American artists who devoted the major part of his life to painting religious themes. Critics have said Congdon's works are close to divine inspiration. His crusty style contributes to the intensity of his painting. Layer upon layer builds to a sense of sculptural relief. His painting illustrates the theme of the Crucifixion while incorporating various famous European cathedrals.

After serving in the United States army in Italy, he remained in Assisi for the last 50 years of his life, which he spent traveling and painting the cathedrals of Europe. Each painting is a modification of another. Paintings of the Crucifixion vary little from one another. His painting titled *Crocifisso 2*, painted in 1960, comes close to an identification of the figure of Christ. An extreme execution of the Abstract Expressionist movement, *Crocifisso 2* is defined with a few strong vertical swipes of the brush. The elongated bodies are distorted and represented by seemingly reckless swipes of color. The cross seems insignificant since it blends into the background, which is darkened to suit the atmosphere of the event.

The head of Christ is a circular glob of color with hair and thorns scratched into the surface. So complete is the distortion of the figure of Christ that one is reminded of a shank of meat hanging in a butcher's freezer. This physical structure of the human body was painted swiftly, preceded by a deliberate and careful consideration. So what appears as a sloppy distribution of pigment is in actuality a positive touch of the brush to canvas. It is an expression of an unusual moment of pure joy.

William Congdon's 1960 *Crocifisso 1b* differs from *Crocifisso 2* in terms of its crusty application of pigment. Instead of black and gray tones monopolizing the

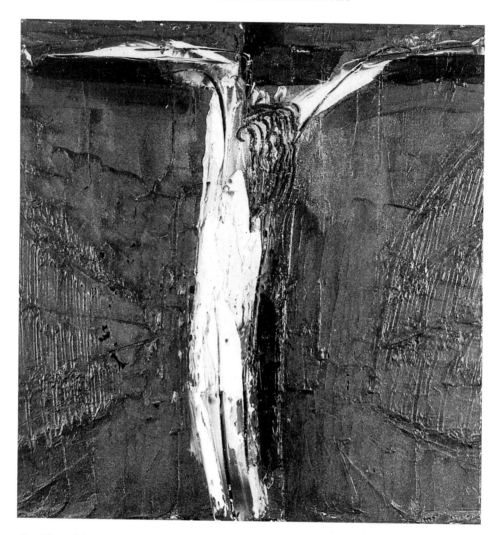

Crocifisso 1b by William Congdon (1960). Oil on panel. 35 × 33 cm. The William G. Congdon Foundation Collection, Milan, Italy.

background as in *Crocifisso 2*, Congdon has treated the environment with a combination of painting, gluing, scratching and re-painting. The result is an emotional depth and a dramatic contrast of texture between the environment and Christ. The painting reveals the image mangled in extremely torturous positions. The body is vertically elongated with smears of color identifying the segments of the body. The head of Christ is bent forward, revealing the hair and crown of thorns. The background resembles the texture of the cathedral walls of etched symbolism.

Congdon was concerned with composition, not in the sense of balance and

Opposite: Crocifisso 2 by William Congdon (1960). Oil on board. 89 × 59 cm. The William G. Congdon Foundation Collection, Milan, Italy.

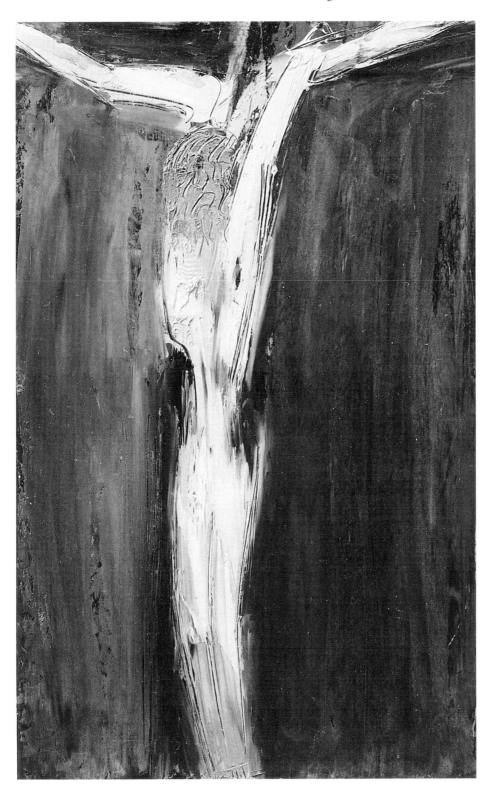

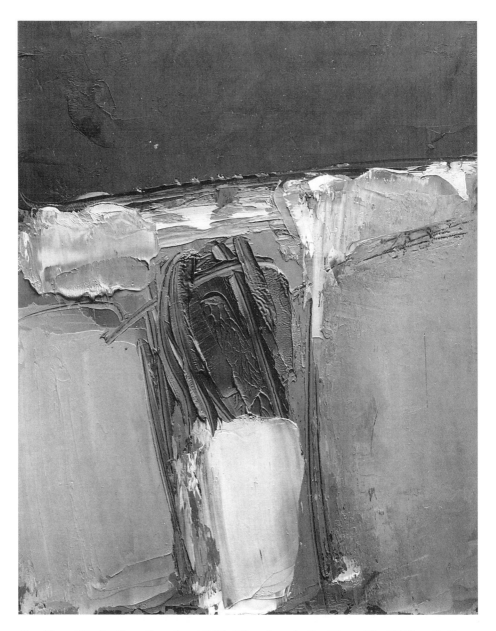

Crocifisso 46 by William Congdon (1969). Oil on board. 60 × 50 cm. The William G. Congdon Foundation Collection, Milan, Italy.

equalized distribution of color, but in the delivery of his message. Although several artists have focused on the tortured features of the human body, Congdon amassed all features into a single factor. In other words, facial gestures were understood to be present. The singularity of subject matter dominates the canvas surface. He has expressed strength and tenderness in the figure of Christ, but has overemphasized the agony suffered by Christ. And yet, the seeming over-

playing of pain coincides with the profound faith that prevailed within the artist's inner spirit.

It is indeed a difficult task to combine the tender nature and the physical strength of the victim. The casual viewer may not appreciate the direct, impulsive nature of Congdon's *Crocifisso 1b*. In much of society it might well be rejected as ugly and worthless, but with proper training one could see in it the devout faith of the artist.

The intuitive process of painting is difficult because too often it becomes a hit or miss procedure. Artist William Congdon was a master at reacting fluently and emotionally to the notion of the Crucifixion. In his 1969 painting titled *Crocifisso 46*, he revealed with a few broad strokes of the brush, seemingly recklessly employed, the deep agony and humiliation suffered by Christ. Congdon's work was conceived at length and perhaps executed in a lesser period of time. *Crocifisso 46* is an image revealing a total of six major areas. The upper section is totally dark, lacking all communication, but by its mute appearance it adds to the significance of the theme. Broad brushstrokes accompanied by linear slashes of color make for a dramatic and intimate intercourse between artist and his idea. Pigments are displayed in tiers of color, wet on wet, the process being a difficult one.

Viewing *Crocifisso 46* reveals no bloodshed, no human forms and no mourners and audience. It is not traditional. One reacts emotionally to color and the bold slashes the colors represent. And in the case of most great art, the intimate nature of the painting eludes the viewer because the viewer is the outsider. The artist does not paint nature; he paints the image of nature. Congdon has painted his extremely personal image of the Crucifixion, difficult indeed to understand. Viewing his work in retrospect would enable one to appreciate it. There is a crossbar suggested in *Crocifisso 46*, the head of Christ and the lower torso. Because of the simplicity treated in an intuitive manner, Congdon's painting creates immediate audience reaction, both favorable and unfavorable, for his work has finally reached a broad range of expression.

Berkley Chappell

He Wins by Losing, a 1967 painting by Berkley Chappell, is a rare and unusual expression of the Crucifixion. The skeleton of the crucified form reveals the death of Christ. Death has occurred *and the agony and humiliation have ceased*. The image of Christ is not attached to the cross; instead, the remains of a mortal being are fixed there and have not been lowered from the cross as in the traditional manner. There are no mourners, no criminals, and no spectators. The viewer faces the image of death. The winning of the title refers to the Resurrection. Christ has conquered death.

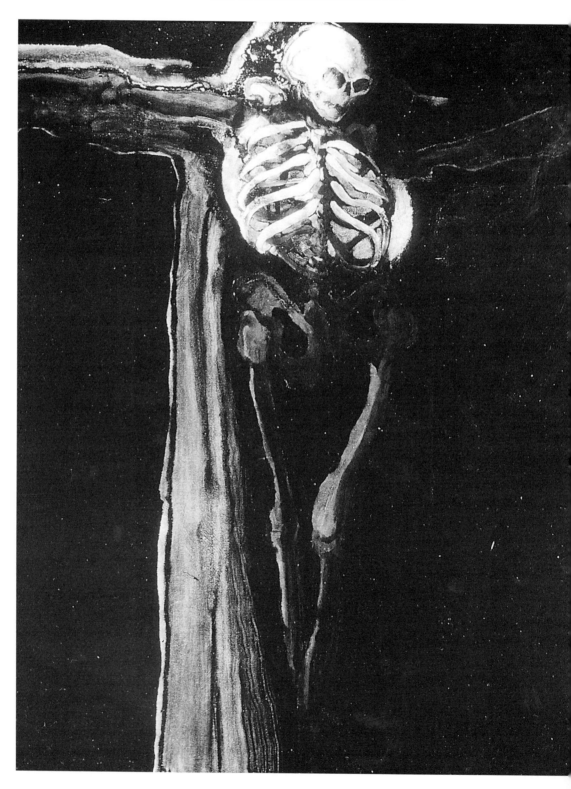

The artist has focused on the head or skull of the crucified. The lower torso tends to fade, lacking in detail. The viewer is forced to acknowledge death in its most basic form. Chappell has forced the viewer's attention to the upper part of the painting and allowed the lower section to blend into the darkened background. Christ's skeleton is painted in brown and black except for the skull and ribs which are expressed in pure white. The background is black serving as a basic color, and the figure of the crucified Christ and the cross were applied last.

The composition has an active detachment of the Christ figure and the cross suggesting that death has occurred. The stark contrast between the background and the subject matter adds to the eeriness of the scene and succeeds in an optical sense to complete the composition. Surrealism is always a deeply personal mode of expression and as such creates a problem for the viewer. The surreal approach to the theme here suggests several interpretations. The title makes the meaning more palatable: to lose the small points in order to win the main event has been appreciated for many years. Using the title as a departure point will make an interpretative decision easier.

Frederick Brown

Stagger Lee, a 1984 painting by Frederick Brown, is an intricate intermingling of different personalities. It includes several schools of thought: Primitive, Abstract Expressionism, Abstract and others. It includes the top and front views of what appears to be an urban area, but intermixed with seemingly abnormal human figures. There is no sense of visual perspective as human forms overlap with a disregard to physical proportions.

Facial features are bewildering, with looks of suspicion, fear, indifference and caution. Brown has utilized the symbolic three crosses, placing them in a remote corner of the painting. The crucified Savior is revealed in an obscure section of the painting, too insignificant to describe since all details of the crucifixion are missing. Five humans become visible not as mourners but as celebrants. The viewer may be puzzled when gazing upon the seemingly disorganized composition. The abnormal and primitive figures could well be spectators, but it is difficult to determine the artist's purpose. Hands, feet and facial gestures appear are exaggerated and distorted in a childlike fashion. As figures overlap, each becomes a victim of the viewer's search for identity.

As the image of the crucified Christ diminishes into the background, the crowd of differing personalities dons 20th century apparel. This places the event of the crucifixion centuries apart from that of the crowd of spectators.

Opposite: He Wins by Losing by Berkley Chappell (1967). Oil on canvas. Courtesy of the artist.

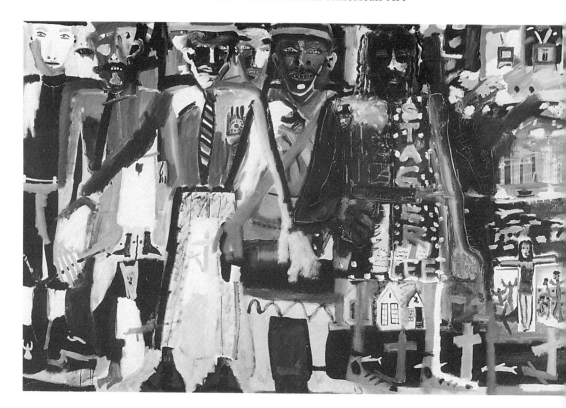

Stagger Lee by Frederick Brown (1984). Oil on canvas. 90 × 140 in. Smithsonian American Art Museum, Washington, D.C., Museum Purchase, ©1983, Frederick J. Brown.

Brown's version of 1984 is an example of the axiom that there is no definite trend in the expression of art. Here he uses intuitive reaction to an idea to express the Crucifixion of Christ. In spite of the complexity of the composition and its objectivity, *Stagger Lee* comes off as a subjective expression because of the overlapping and interpenetration of images to create a oneness of images.

Grigory Gurevich

Contour lining and doodling possess similarities depending on the approach to an idea, whether it be direct or wandering without a preconceived notion. In Grigory Gurevich's 1986 drawing titled *Energy Circles*, lines are contour because of the consistent deliberate control of their direction and because of a definite conclusion to a given idea. The single subject of the crucified Christ demands the

Opposite: Energy Circles by Grigory Gurevich (1986). Pen and ink. 18 × 14 in. With permission of the artist, Grigory Gurevich.

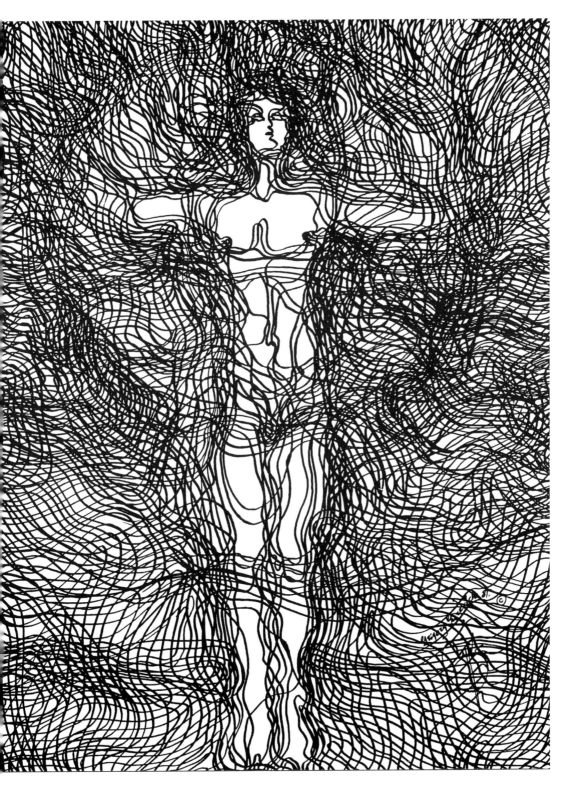

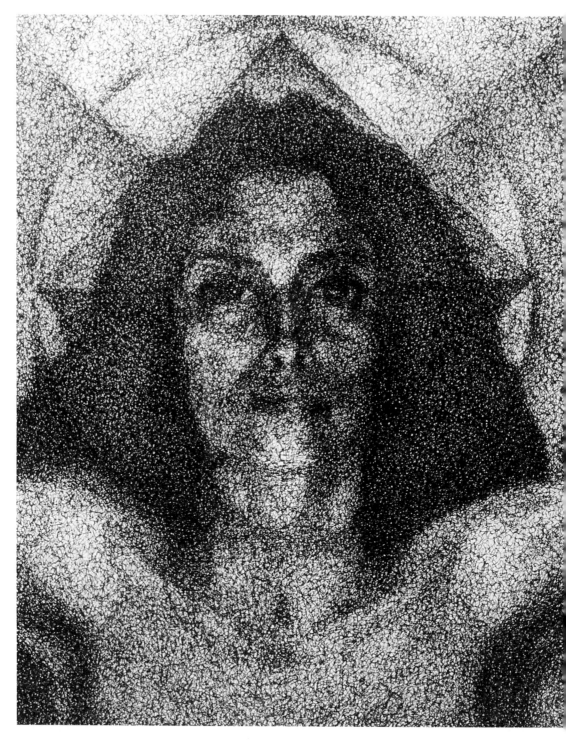

Awakening by Grigory Gurevich (1986). Pen and ink. 21 × 16 in. With permission of the artist, Grigory Gurevich.

viewer's total attention in spite of swirling backgrounds of overlapping lines. Each meandering line is a segment of a geometric shape; in aggregate, the lines resemble a jungle contained within the given working surface. The figure of Christ is allotted fewer lines in order to free it from the outer environment; thus it stands alone while featuring the physical structure of the work.

Lines appear to be without beginning or end. The background is a singular execution of overlapping lines; the tones of gray they create vary according to the closeness or distance between them. The fewest lines appear to form the Christ figure, but they are always connected with the background.

There is no visual perspective in the traditional sense. No baseline, middle ground or sky line is present. Therefore the crucified Christ appears on a vertical plane. Physical features are not apparent other than the facial features which suggest a dual gesture of expression. The image of Christ is overwhelmed by the regularity of contour lines which all but consume it. Although Abstract, *Energy Circles* retains a traditional appearance. It is formally balanced which makes for a casual acceptance.

Not only is a message forthcoming, but the work itself is acceptable as a work of art regardless of content. Even though *Energy Circles* is a swirling mass of lines seemingly moving nowhere in particular, the complete expression is also a complete idea in a manner compatible with the artist's current approach.

In Grigory Gurevich's 1986 drawing titled *Awakening*, he preferred that the facial features of the crucified Christ not display the suffering, anguish and humiliation of his death. The artist's technique is traditional and avoids extreme distortion. Gurevich has produced a realistic portrayal, slightly geometric in style, with a hint of Abstractionism. Mental strength is evident in the set jaw and piercing eyes which seem to demand viewer attention.

In *Awakening*, executed in the Impressionistic style, the artist has forsaken all signs of agony and instead set up a form of compromise. The thousands of minute circular doodles, however controlled, form the various tones of darks and gray areas in contrast. The head and shoulders were drawn in the academic or traditional manner. It is the fulfillment of space and the shapes formed by this fulfillment that present a charming figure in spite of the circumstances.

Christ's head is perfectly balanced as the head and shoulders share equally the areas on either side of the center line. There is no crown of thorns, but a halo surrounds a formally balanced head of hair. The slight background executed in a manner similar to that of the head of Christ pierces the halo from opposite directions creating a sense of the casual. As in his *Energy Circles*, Gurevich has executed an extremely tight pattern of lines, painstakingly applied. One must appreciate the control and patience the artist has employed.

Gurevich's image of the Crucifixion represents rebirth, not death. In this regard, *Awakening* has been misunderstood, as the most ostensibly academic works of art often are.

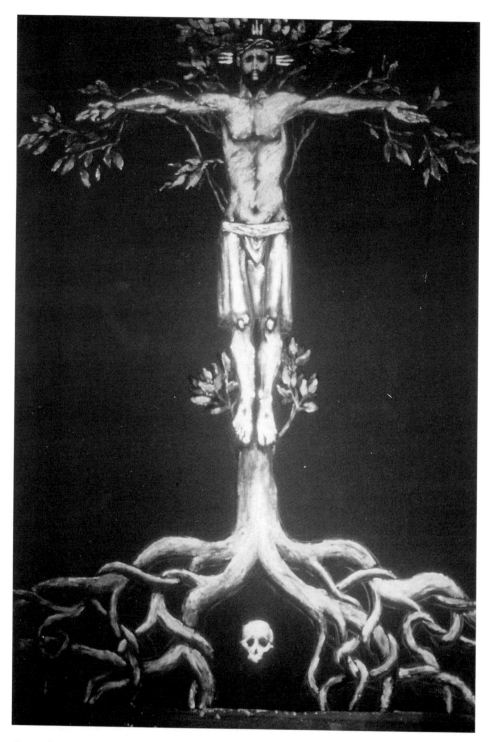

Central Lenten Hanging by John Steczynski (1987). Wall hanging. Courtesy of the artist, John Steczynski.

John Steczynski

John Steczynski's 1987 portrayal of the crucified Christ involves the forth-coming Resurrection. The branches of green leaves appropriately positioned around the body of Christ symbolize his rebirth. The artist has placed him on the central area of the working surface, declaring the significance of the crucified Christ. Surreal in appearance, the composition suggests a formal balance, not so much from similar images, but from the visual placement of images whether similar or not. The background is total darkness with the figure of Christ seemingly floating in the air. A skull identifies with the crucifixion site. The gnarled roots of the tree on which Christ has been crucified surrounds the otherwise isolated skull as if to indicate the permanent site of this murderous display. The roots of the tree overlap and intertwine to form a hint of prison, an impossibility of escape.

The figure of Christ is realistically portrayed, but it is only slightly distorted and therefore lacks the agony and anguish he experienced earlier. Steczynski portrayed Christ as a symbol of eternal life. *Central Lenten Hanging* is well conceived and executed. Details are handled with precision. Even though scars of the torture of the hands, feet and chest are revealed, there is no excessive bloodshed.

This is one of the few crucifixion works that utilize the tree image for the cross. The artist has granted it perfect balance. The disciplined posture of Christ suggests a determination to withstand any degree of agony. The image of Christ is similar to light emerging from the darkness, it seems to be saying that a new life is beyond the horizon. *Central Lenten Hanging* is both symbolically and intellectually a challenge. This provocative piece has earned the viewer's further study.

Jon Rappleye

Springtime Crucifixion suggests Easter Sunday. Painted by Jon Rappleye in 1993, it represents a rebirth, a resurrection in spite of the figure of the crucified Christ. Intermixed with the three crosses are flowers and tree foliage, a typical sign of spring. The image of Christ is centrally located and although the other two crosses are evident, the crucified forms are not. The crosses blend with the forest of trees so that the crucified Christ is not readily noticed. Flowers in full bloom are attached to the side of Christ and to the base of the cross.

Two miniature figures attired in bright red gowns stand in prayer beside Christ. They represent two of the weeping Marys. An unusual blend of Realism and Impressionism dominate the scene. The figure of Christ is realistically formed, creating an immediate response from the viewer. There are moments of

Springtime Crucifixion by Jon D. Rappleye (1993). Oil on canvas. 50 × 60 in. Springville Museum of Art, Springville, Utah.

confusion as the environment presents a mixture of greens, but in a continued viewing, tree trunks, branches and leaves and grassy areas form a unique one-ness. And since the figure of Christ is in colors similar to that of the tree branches, there appears a gradual rectangular composition.

Rappleye has used the childlike theory of perspective. A baseline appears at the base of the painting and is topped with the sky area, leaving in between a middle area which creates a horizon line. *Springtime Crucifixion* is complex. The artist has presented the Crucifixion and the future Resurrection in a single expres-sion. It demands a thorough viewing of all areas of the work, but the image of Christ is the dominant feature. Further study will uncover the three crucified criminals partially hidden by the dense forest areas. The relationship of the crucified figures forms a three-dimensional composition within a larger format. Rappleye has painted a provocative image of death and life, death of the crucified

The Crucifixion Triptych by Todd Stilson (1990). Watercolor. Springville Museum of Art, Springville, Utah.

Christ and the hope of the future, with the presence of the rebirth of spring, a truly noteworthy expression.

Todd Stilson

The Crucifixion Triptych by Todd Stilson involves three complete compositions. Painted in 1990, it is a triptych that would succeed as a mural or three-easel painting, each plate relating its own story as well as combining to make a single-easel painting. Compositionally, each plate serves one another. An advantage of this is that each section can be appreciated on its own merit. The Crucifixion of Christ occupies the central panel and as such rates commentary. The painting, although vertical in composition, has four horizontal shapes—baseline, middle ground, mountains and sky. All shapes are joined together by overlapping. Two figures in the foreground overlap in the middle ground while the crucified Christ on the cross and a figure offering Christ a sponge laden with vinegar overlap the remaining three shapes. The sky is clear and bright, exhibiting no signs of the oncoming death. In fact, there is no bloodshed, no appearance of agony or torture.

The left panel reveals a strong vertical occupying the left side of the canvas. It differs from the middle panel in that there is a lack of recession in the plains in the middle panel, and in the left panel, the mountains appear in recessive order. The dominating feature is a human being swallowed by a large fish, possibly a rendering of the story of Jonah (Jonah 1:17). The right panel is also anchored by a strong vertical building. There are mountains in the distance, too. Settled within the central aspect of the right-hand panel are two figures and a

mule which could be interpreted in various ways; they resemble Abraham and Isaac in the story of Isaac's near sacrifice (Genesis 22:1–19).

Religious triptychs were common during the European Renaissance. To find a total painting split into three sections in the year 1990 is rare. Shadows create sharp contrasts, making for a dramatic appearance, while their distribution guarantees a unified composition.

Karen Gunderson

First Crucifixion by Karen Gunderson hints at the Renaissance era, but inserts the artist's personality and faith, and as a result a compassionate and intuitive response occurs. The 1990 painting is a vertical work. Gunderson's unusual style coincides with the activated sense of the Crucifixion. The crucified Christ is pictured as if he had given his all. The agony and suffering have passed. His arms form a V-shape as they are stretched to the limit. It is not unusual to present Christ without an audience. One can only guess that the spectators had left the scene. Also, the artist preferred to concentrate on the crucified Christ and not share emotional and intellectual responses with the viewer.

Gunderson has used both the Realist and intuitive processes of art. The crucified Christ is realistically drawn with an individual style peculiar to the artist alone. Brushstrokes appear as a body wrap instead of flesh. And yet, the physical appearance emerges. Although his feet overlap, revealing but a single spike, both legs are acknowledged even though one leg covers the other. Gunderson has used the sharp contrast of black and white to advantage in the background surrounding Christ on the cross.

The sweeping circular brushstrokes aid in sustaining a focus on Christ. This technique creates an exciting background which becomes activated and avoids a vacuum. The same circular movement is employed as that used to create the figure of Christ, but it is done so with a more closely knit application. The crown of thorns pierces the brow of Christ, and thus creates a flow of blood down the side of his face. The size of the canvas (99 by 60 in.) makes *First Crucifixion* even more impressive.

John Talleur

The Burial, a circa 1959 woodcut by John Talleur, is a delicate but emotional expression of the entombment of Christ. The delicately rendered details are the work of a master printmaker. *The Burial* is a view from above although it appears

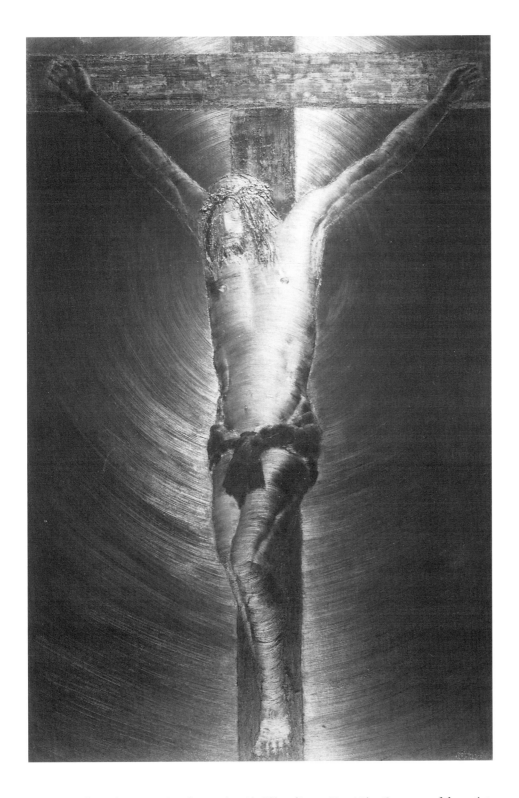

First Crucifixion by Karen Gunderson (1990). Oil on linen. 89 × 60 in. Courtesy of the artist, Karen Gunderson.

The Burial by John Talleur (1959). Woodcut. 21½ × 50½ in. Oklahoma City Art Museum, Oklahoma City, Okla.

as a vertical composition. Christ, whose hands overlap in a manner similar to that of his feet, is not only an emotional device but a key to an unusual composition.

The positioning of the red blood marks result in an obvious compositional technique as the viewer scans the vertical figure from feet to head. Anatomical display is undefined in certain areas because of what appears to be an overplay of details. And yet, it is precisely these details which make *The Burial* an exciting expression of an emotional event.

It is strange perhaps to produce depiction of death that results in an emotional discharge. But the muteness and silence of a lifeless body continue to reflect the agony and humiliation of life. The display of hands which originate outside the limits of the working surface offers a consoling effort to redeem oneself. This unusual arrangement of anatomical segments does not create visual interference since the hands are presented in horizontal planes that complement rather than abuse the total composition.

Talleur's unusual approach to a horizontally positioned subject results in the appearance of a vertical contrast to the outstretched hands of the mourners. The viewer is tempted to relate to the extreme edge of the woodcut but always returns to the battered body of Christ.

The artist has purposely overlapped Christ's feet as they appeared on the cross. Christ is the figure of death and it is as if he is lying in a coffin being readied for burial. Death is sorrowful. Although the crown of thorns is no longer present, the effects remain in the presence of blood streaks on his face.

Talleur is a master of the unusual. His compositions are personal and reflect an intimate concern for his subjects. *The Burial* is the perfect title for this unpredictable and unique expression.

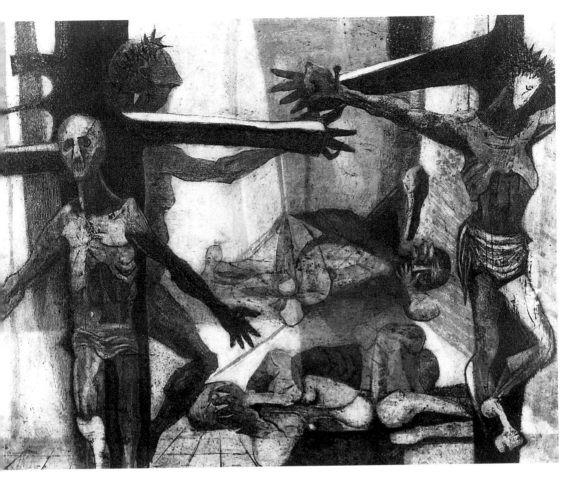

I Stretched Forth My Hands by John Talleur (1955). Intaglio color print, #4 of 9. Plate measurements: 19 × 24 in. Joslyn Art Museum, Omaha, Neb.

John Talleur's etching titled *I Stretched Forth My Hands*, a 1955 production, is far more complex and symbolic than his later woodcut titled *The Burial*. Extremely dramatic, it reveals three crucified figures and two deceased lying down in the background. The dynamic Christ pictured on the far right of the painting is physically distorted and features a jagged crown of thorns piercing his forehead. The hand of one of the thieves barely grasps the strong right hand of Christ.

The unusual composition reveals two crosses but three figures. Christ occupies the cross facing the viewer, while the second cross pictures the two thieves occupying opposite sides of it. The thief facing the viewer is an exaggerated form with arms hanging. Talleur has depicted the termination of life in its extremity, revealing a skeletal form, flesh already consumed with time.

A strange occupation occurs in the background. Two figures lie in a seemingly lifeless condition; yet each portrays signs of previous pain, and both cover their faces as if witnessing a horrible sight. Talleur has utilized vertical and horizontal planes

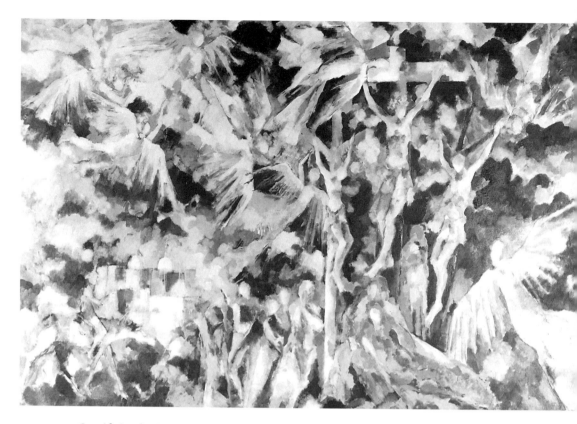

Crucifixion by James Van Dyk (date unknown). Oil on canvas. 65 × 94¾ in. Joslyn Art Museum, Omaha, Neb.; Gift of Dr. Leon S. McGoogan.

to advantage in creating a unified composition, almost bringing together segments of all human forms into a oneness. There is no settling down to a single aspect because of the unifying forces created by the activities generated by the theme.

To compensate for the lighter areas of the etching, the artist has injected appropriate shadows which serve the background as well as the figures themselves. There is a unique blend of black and white areas enhanced by several levels of nuances, without any loss of the dramatic sharpness of the print. Talleur has created a remarkable example of the print process without forfeiting symbolic images. The viewer does not hedge on *I Stretched Forth My Hands*. The message is clear.

James Van Dyk

James Van Dyk's 1956 rendition of the Crucifixion is an amazing juxtaposition of colors and figures. The three crucified victims intermix with the usual characters once exhibited in the European Renaissance paintings. Van Dyk's Crucifixion, though, is different in style — it is in a revised form of Impressionism. The composition resembles a Tintoretto. The three crucified figures are not

readily defined. The several figures surrounding the three crucified beings do not clash but overlap into a montage of human anatomy. With diligent study one discovers the image of Christ and the two criminals, the weeping Marys, other mourners, the Roman soldiers and the numerous angels.

There is no foreground or background, no visual perspective, but there is a display of exciting brushstrokes on a frontal plane. One can best appreciate *Crucifixion* as a total painting rather than using a seek and find approach. The Crucifixion of Christ is present but sustains no more significance than the other images.

The blotches of color were not randomly applied because, with a close look, one could identify each character. The figure of Christ is actually downplayed as if to place all characters involved on equal terms. That is partially the beauty of *Crucifixion*. The message is there but it seems as if a celebration is about to transpire. There are no spikes pinning Christ to the cross or crown of thorns piercing his brow, or blood streaming from his pierced side. There are no signs of torture or agony.

A detailed study would reveal the possibility of the Ascension as well as the Crucifixion since the arms of Christ extend upward and are not nailed to the cross. James Van Dyk has created a realistic portrayal and altered it to fit the Impressionistic school of thought. Figures are detectable as one notes the Realistic style beneath the coverage of carefully conceived and applied patches of pigment.

Howard Warshaw

Titles can be confusing, making it difficult to understand and appreciate a work of art. Such is true of Howard Warshaw's painting titled *Deposition in the Street*. Adding to the unsettling title is the style of Abstract Expressionism the artist has used, which is an intuitive approach to an idea. As one looks at *Deposition in the Street*, one sees the intricate interpenetration of forms and colors. A single scan of this painting, with its subtle distinctions in shades of blue and violet, would not begin to lead to an understanding. The viewer must learn to discover the relationship of color adjacent to color separated at times by a single line.

The figurative form strongly suggests Christ's body being lowered to another surface. The torso of Christ is centrally located with arms and legs hanging in mid-air. A figure on the extreme right of the canvas is phantom-like in appearance with only the outer garments in view.

There is no attempt at realism. The colors white and blue aid in the compositional efforts as they act to define shapes and to balance the painting in an informal manner. There is a hint of Grünewald's *Crucifixion* which continues to reflect the influence of the European Renaissance. However, Warshaw (born in 1920) gives no date for his work. *Deposition in the Street* seems to suggest a broad expanse of the theme itself. Not only was Christ crucified, but so too was the entire

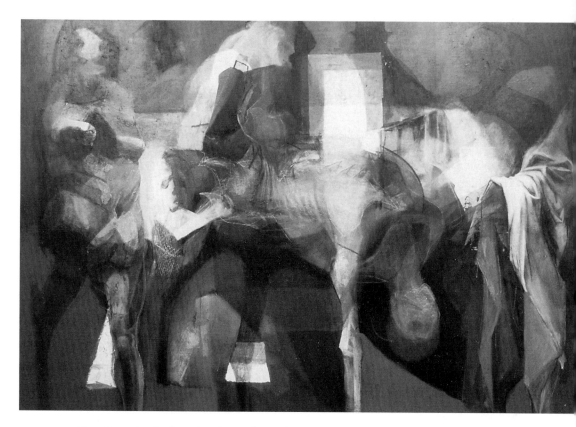

Deposition in the Street by Howard Warshaw (date unknown). Acrylic on canvas mounted on masonite. 50 × 70 in. St. Lawrence University permanent collection, Canton, N.Y. Gift of the Childe Hassam Fund of the American Academy and Institute of Arts and Letters.

world. Thus, Warshaw has used the title to identify with the sorrows and suffering of society. *Deposition in the Street* has not revealed a complete figure nailed to a cross. There is no pain, no torture, no bloodshed, and thus one wonders if this portrayal defines the crucified Christ or society as a whole.

Warshaw's portrayal is profoundly personal, which makes it more intriguing to interpret. A viewer missing the message of the artist may well enjoy the composition with its variation of colors and shapes, but understanding an intricate abstract advances the viewer to the understanding of future works. The subtlety of form and the cross itself permit a convincing blend of the foreground and background.

Brother Kyran Aviani

In viewing *Crucifixion*, a 1961 work by Brother Kyran Aviani, one's emotions could well surge upward and slowly diminish to a solemn genuflection. The

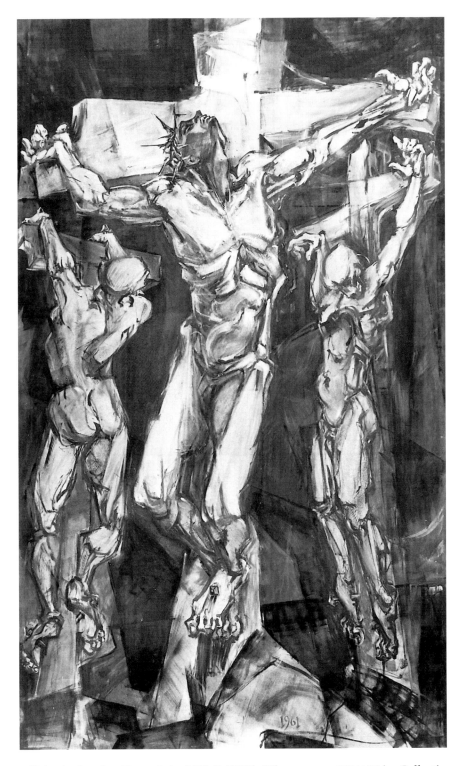

Crucifixion by Brother Kyran Aviani F.S.C. (1961). Oil on canvas. 120 × 72 in. Collection of the Hearst Art Gallery, St. Mary's College of California, Moraga, Cal.; Transfer from the Christian Bros.' Retreat House; Gift of the artist, Brother Kyran Aviani F.S.C.

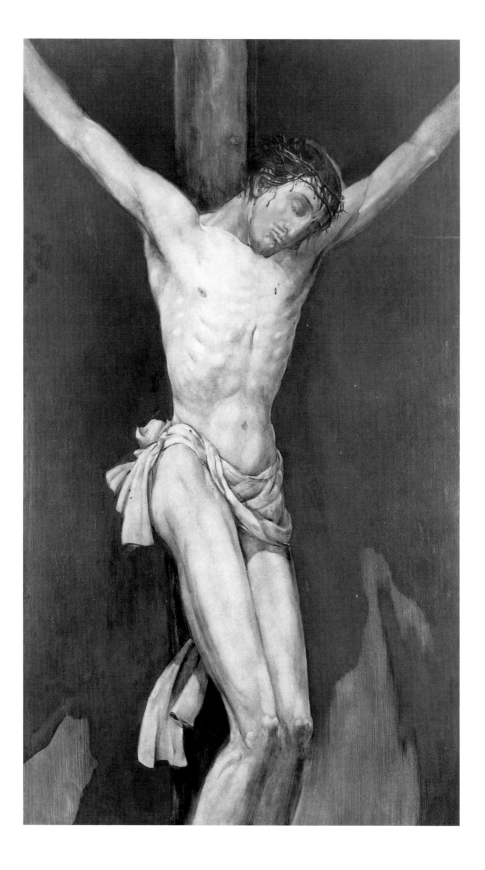

power that the artist has produced and sustained within a limited framework is startling and creates a sense of unlimited grief for the victim. Christ in particular, occupying the central position, is treated with unreserved caution. The two crucified victims to the left and right sides of Christ are totally different from each other. The figure to the right is nailed through the wrists while the figure to the left is nailed through the back of the hands. Although extremely distorted, Christ's head is crowned with thorns shaped like daggers and his neck is elongated as he searches heavenward for an answer. His entire body is muscular, and its distortion is the result of the agony he is suffering.

The cross is painted as if constructed with slabs of cement. This device adds to the solidification and the permanent nature of the material. Furthermore, it strengthens the entire painting because Christ and the cross appear to be one. The brutal depiction seems surreal, and yet considering the degree of agony and frustration, it nonetheless must be classified as a realistic portrayal.

The painting is large, measuring 120 by 72 inches, and because of the partially inactive background, the three subjects demand full attention. Aviani, with quiet and technical brushstrokes, has blended the figures with the background. And allowing a dark background befits the time of death.

The cross is more than a vertical post with a crossbar—it is treated with vigor and intensity. Thus, *Crucifixion* is a full and complete painting. The space of the entire canvas is used to fulfill an image of Christ. The two criminals and Christ form a strong rectangular composition. Brother Aviani's *Crucifixion* is a major masterpiece, one which demands not a mere glance, but several visitations.

Joseph Thurman Pearson

The painting titled *In Vain* by Joseph Thurman Pearson is an oil painting on wood. And since it contains a strong element of the European Renaissance, it seems to belong more to America's 18th century tradition. The unique difference is that Pearson's portrayal of the body does not reveal the nailed hands and feet. This is an extreme example of a personal and intimate expression. It reveals Christ's limp body ready to be removed from the cross.

The title, *In Vain*, seems to suggest that the death of Christ is hopeless, that the figure droops in despair. The body hangs in complete darkness, allowing a positive approach to viewing the figure of Christ. There is no audience. Christ is alone. The omission of mourners and well-wishers reflects a rigid concern of the artist as if he preferred sole possession of the moment.

Opposite: In Vain (formerly *Crucifixion*) by Joseph Thurman Pearson (date unknown). Oil on wood. 64¾ × 37¾ in. Courtesy of the Pennsylvania Academy of the Fine Arts, Philadelphia. Gift of the artist's family.

The image of Christ appears so peaceful that it forces the viewer's undivided attention, a display ready-made for acts of meditation and contemplation. The head is turned to his left, resting on his arm and shoulder. The crown is obviously the sole sign of pain and yet there is no pain. It has subsided. Because the background is dark and the foreground (figure) is light, the combination forms a perfect contrast, and a contrast of two completely mute moods. The painting is totally subjective because of a total absence of elements misleading the viewer's vision. Adding a figure within the darkened environment would cause an exchange of attentiveness between Christ on the cross and the element within the background. The painting is also vertical which disallows any interference from any horizontal placement. Thus, the viewer cannot possibly ignore Pearson's expression. An initial glance would likely be emotional and the longer the gaze, the more emotionally attached the painter and viewer would become. Pearson's expression is one of reparation, a display of atonement. The painting is inactive, and yet it contains a strong element of emotional stillness. Pearson's *In Vain* is an American expression of the Crucifixion reminiscent of the European Renaissance.

Steve Hawley

Steve Hawley's dramatic 1972 version of the Crucifixion of Christ combines two extreme styles, the foreground in a Realistic style and the crucified Christ in the style of the Abstract Expressionist movement. Its contents pose a question — which came first, the loose, seemingly reckless application of pigment, or the meticulously rendered foreground? An answer, however, is not essential for a total and complete appreciation of *Root of Jesse*. Frequently, artists intermix or blend differing techniques. However, Hawley's approach is definite and purposely rendered. The quiet nature of the foreground is an essential contrast to the intuitive style applied to the background or to the crucified Christ which occupies much of the background.

Christ's body, severely tortured, is executed in an intuitive manner and joins forces with the background. The interpretation of the foreground in conjunction with the rough texture of the crucified form is questionable. However, the artist apparently had little difficulty accepting it as total and complete. To alter any segment of it would destroy the painting — its meaning, its composition and its application of pigment.

There is an odd appearance of the visual theory of recession and advancement of color. There are areas of applied pigment which seem afterthoughts. Nonetheless, these areas go unnoticed until a deeper view of the painting occurs. The image of Christ's body is totally executed with broad swooping strokes of the brush. Blood spurts from Christ's right side, but more than a second glance

Root of Jesse by Steve Hawley (1972). Smithsonian American Art Museum, Anonymous Donor. ©1986, Steve Hawley.

is needed to recognize the flow of blood. With careful and sustained study, *Root of Jesse* comes alive and the drama of the Crucifixion unfolds. Hawley also relied heavily on the distribution of darks and lights which hold the composition in place.

Umberto Romano

Ecce Homo is an insufficient title for Umberto Romano's painting. The power of Christ's physical body reveals the strength and physical pain more than a crown of thorns. And yet, one is visually attracted to the brow of Christ as thorns pierce his powerfully rendered head. *Ecce Homo* is a masterpiece, and Romano's approach is not unlike that of artists of the European Renaissance.

Romano was an expert at subtracting light from dark. His style of scraping color from color to strengthen contrast between segments of the body of Christ was a powerful approach. Presenting Christ to his people, Pilate, whose head and arms form the left side of the composition, receives identical exposure to Romano's technique. The two partially exposed figures form a strong rectangular composition. Little use is made of the sky background. The remaining space is dramatic in its swirling movements of clouds which coincide with appropriate locations on the two figures. A triangular creation is formed by three major figures—Christ's head, his roped hands and the head of Pilate.

Romano has formulated muscles by highlighting appropriate areas by scraping colors to form lights adjacent to darks. His painting is tightly knit and allows no special areas to interfere with the compact nature he created. Contour lines were also formed by the same scraping style.

Perhaps Romano's title, *Ecce Homo*, is fitting since the head of Christ appears to be the most significant aspect of the entire painting. The thorns crowning his head are sharp, angular, short dagger-like darts that draw blood extensively. Romano's style prevails throughout the painting.

Considered a religious painter, Romano was hailed by critics as the forerunner of American Renaissance. His most dramatic works stem from the Great Depression and World War II. *Ecce Homo* is from a little after—it was executed in the year 1953.

Opposite: Ecce Homo by Umberto Romano (1947). Oil on canvas. 40 × 28½ in. Courtesy of the Pennsylvania Academy of the Fine Arts, Philadelphia, Pa. Gift of Dr. and Mrs. Abraham J. Rosenfeld in honor of their son, Richard.

The Transcendent Function by Karen Guzak (1991). Crayon on paper. 4 × 4 ft. Courtesy of the artist, Karen Guzak.

Karen Guzak

The Transcendent Function, by Karen Guzak, is a display of overlapping crosses which advance and recede into space. The crosses and general geometric shapes flow to and fro on the picture plane but blend together to become one. The major cross divides the expression into four equal squares, each forming its

own composition. Made up of incomplete geometric shapes, there seems to be no beginning or end. However, a strong suggestion of cross images floats throughout the painting.

The Transcendent Function is a vibrant 1991 painting shimmering with fiery colors which hint at Op Art. The narrow cross dominating the central area of the painting is energetic, almost electrifying. The figure of Christ is assumed to be present on the cross. The swirling lines painted in both vertical and horizontal shapes within the cross do not create a figure of Christ but suggest life.

Guzak has gathered together the transparency of watercolor and the opaque nature of casein. The entire painting is symbolic. Abstract symbols represent the participants of the event at Golgotha. Abstract expressions of art offer numerous interpretations, and *The Transcendent Function* is no exception. The colors symbolize the physical aspect of art — images such as red for blood, violet for sorrow, black for death and yellow for forthcoming rebirth. As the painting progresses newly discovered symbols are appropriately applied to finalize the composition.

Visual perspective is slightly noticed. The entire painting rests on a single forefront which constitutes layers of pigment receding and advancing in the picture plane, creating spatial effects not readily acceptable.

Nancy Ori

Nancy Ori's 1995 Crucifixion scene, titled *Jesus*, is actually a photograph of a cemetery tombstone. The crucified figure of Christ is brutally deformed, not in an intentional way but in an innocent, childlike approach. Christ's arms are straight board-like poles, without muscles and skin-like tones. Drops of blood trickle down his body. His arms and hands, although not nailed to the cross, act as a compositional feature not only in splitting the background and avoiding monotony, but in incorporating excitement into an ordinarily absent or mute area of the photo. The primitive nature of the portrayal makes it seem earlier than 1995. Thus, the work could have been executed centuries ago but photographed in 1995.

The crown of thorns created spurts of blood which speckled his face and segments of his upper torso. The face of Christ reveals extreme agony almost to the point of death. His eyes are opened one moment, then closed. Ori's work demands attention. The photograph is a humble display of excruciating pain. Through her camera placement and positioning of herself, the artist only reveals enough of the tombstone to perfect a photo that expresses the actual suffering by Christ. The background could represent either the meadowland or a series of trees in full foliage.

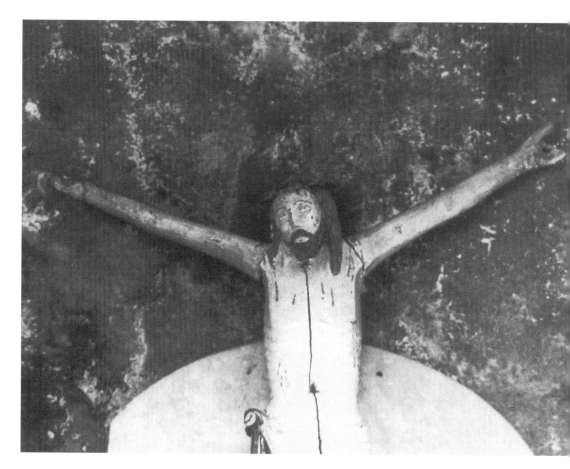

Jesus by Nancy Ori (1995). Photograph. Courtesy of the artist, Nancy Ori. ©Nancy Ori.

Jesus is an intimately compassionate portrayal and Ori used a limited resource to create it.

Thom Lynch

The use of the postage stamp format is indeed a unique approach to the Crucifixion of Christ. Thom Lynch's 1993 *Connectors* uses that format to depict a dual form of the tragedy. The images are exactly alike except for the dimensional size, so that one sees a repetition of Christ's death. The boundaries of the two circular shapes contain the crucified Christ. The two similar images form the eye areas, and the image representing the mouthpiece of a telephone completes the composition. The two images are alike in all respects. The figure of Christ cries out and while in anguish shields his face in humiliation. The image of Christ leans forward as if an attempt at escape were possible.

Connectors by Thom Lynch (1993). Oil on canvas. Courtesy of the artist, Thom Lynch.

Connection by Fred MacNeill (1993). Oil on canvas. 18 × 24 in. Courtesy of the artist, Fred MacNeill.

The background within each of the limited circular shapes is seemingly on fire. Black smoke fills the sky. Artist Lynch has said that the painting was first inspired by a remark by Alexander Haig, in the 1980s, that the U.S. might consider "limited use" of nuclear weapons in battle. Later, in the 1990s, the artist was moved by "all the damage being done in God's name" around the world. this painting was the result. *Connectors* is both realistic and surrealistic. It is also a combination of objective and subjective experiences. The background environment is made of brickwork, but overlaid with a Biblical passage.

A portion of the torso, that is, the body of Christ, is surrounded by a black shadow. Another unique feature of *Connectors* is the lack of mourners and spectators. It is obvious that the artist preferred to constrain any objects that would interfere with a satisfying composition.

Fred MacNeill

Fred MacNeill's 1993 portrayal of the Crucifixion is titled *Connection*. It is Abstract, delicately executed, and in it the artist has displayed all but the figure of Christ. Instead, MacNeill preferred to paint the image of the cross, and in place of the figure he inserted images of blood and clothing. All colors are blended to correspond with the vertical elongation of the cross. A nail is positioned positively in the three appropriate locations, one in each end of the crossbar and one at the foot of the cross. The color red representing blood is blended smoothly with the color brown of the cross. A white loincloth edges the section of blood. The crown of thorns is rendered delicately on the right side of the crossbar.

MacNeill's intuitive response to a particular theme is elegantly accomplished. Streaks of color spread across a vertical surface and end suddenly without creating any disturbances or confusion. The background is considered an aspect of the foreground. And yet, the two are compatible as a result of the mixture of colors which are employed in both foreground and background. A oneness occurs, making the painting subjective. The cross itself is a series of elongated colors dominated by the color brown.

The movement of color is particularly impressive. Each item is significant and yet none dominates the other. The cross alone, because of its occupancy on the canvas, remains the redeeming factor. Although the cross divides the canvas into four separate units, MacNeill was careful to instill an exciting arrangement of color into each unit to avoid boredom or repetition. *Connection* is the perfect title for the aftermath of the Crucifixion.

THE 21ST CENTURY

The 21st century began in the way that the 20th century ended: Fewer American artists painted the theme of the Crucifixion. The artist in approaching the theme appears self-conscious now — not free, it seems, to express such a religious notion. Or if the artist should, it is seldom publicly exhibited because of the communion between the artist and his theme.

Since the middle of the 20th century when Abstract Expressionism was at its peak, less significant art movements have taken place. Op Art and Pop Art were short-lived, as were Photo-realism and Super-realism. As the art world whirls in an unidentified direction, the American artist has produced a repetition of the banal and the commonplace. The creation of art used to be the search for a highly personal style; that has gradually disappeared under the avalanche of commercialism. In spite of the artist's zeal to exhibit, he gave in to society's demands for anything suitable for the wall above the sofa.

However, there are always exceptions. Because of the newness of the 21st century, we must simply wait and see. Artists from various ethnic groups have come on strong since the close of the 20th century. Such groups are gradually relinquishing their ties to tribal and social caste systems while entering the mainstream of American art.

In spite of the creativity they naturally provoke, themes like the Crucifixion continue to be met with diffidence. The reluctance to engender a deeper emotional discharge through such a theme results in the creation of paintings lacking in a personal desire to broaden the original ideas. Instead, creations for the sake of change in the hope of creating a trend and a new school of thought have dominated the initial years of the 21st century.

Candleman by Henryk Fantazos (2000). Etching. Courtesy of the artist, Henryk Fantazos.

Henryk Fantazos

According to Henryk Fantazos, *Candleman* is not the figure of Christ but the image representing Christ. The expression stems from a vision or dream and thus may be classified as surreal. Since it is difficult to understand, Fantazos calls it a miracle, or a mystery.

The image of the candleman faces the viewer with head bent forward and

arms extended in a horizontal manner. Six well-lit candles perform a balancing act upon the shoulders of the candleman. The significance of the six candles is not explained. Even the artist cannot account for their presence.

The atmospheric environment is not unlike that of the Crucifixion of Christ. Humiliation and resignation prevail in the presence of the candleman. His clownish appearance and full costume recall similar versions by other American artists. The foreground is a narrow strip of land while the background is total darkness. *Candleman* is an amazing portrayal creating various interpretations. There is no sign of blood, but because of the insertion of the six candles, the arms of the candleman are extremely distorted. There is a curious look on the face of the candleman. The mouth is closed and the nose protrudes beyond the lower chin. The artist was careful not to allow immense dark areas of the background to offset certain elements of the composition. The four directional movements of the objective elements direct the visionary eye to appropriate areas in order to sustain a complete composition.

Candleman is not the crucified Christ, but Fantazos believes that in a mysterious way one can make the connection. If the artist interprets *Candleman* as Christ on the cross, one must respect his decision as free-spirited. In a sense, *Candleman* is a dream-like version of the Crucifixion of Christ.

Sam Cady

Breakwater, Matinicus by Sam Cady is symbolic of the Crucifixion according to the artist. A cross composed completely of stones and rocks recedes into space but in so doing resembles a human form which ignores all signs of agony and torture. Instead, the rocks are symbolic of chunks of flesh arranged in a manner inviting the viewer to climb the cross while adjusting his balance as he progresses upward. Indeed, an imagination and open-mindedness are essential in appreciating this work. The complex overlapping of rocks reveals both depth and outer textures, and shadows and highlights assist in the general composition.

Considered a metaphor by Cady, *Breakwater, Matinicus* is a 2000 replica of a cross and strongly suggests a mangled figure. Yet because of the intimate and personal nature of the theme, the artist refused to be drawn into expressing a human being, tortured and dying from extreme agony.

For Cady, he expressed his purpose, perhaps thinking foremost of a satisfying composition and secondly of an emotional reaction from the viewer. The crossbar near the top of the canvas represents that to which Christ's hands were nailed. In other words, the viewer is asked to assume the presence of an agonized Christ by virtue of the textural and crude nature of the rocks forming the cross.

Cady's background allows little space for conjecture. The space is empty or negative which adds to the suspense and excitement of the expression by the

Breakwater, Matinicus by Sam Cady (2001). Oil on canvas. 42×62 in. Courtesy of the artist, Sam Cady. Photograph by David Plakke.

added attention granted to the positive nature of the cross. Cady's image is indeed unusual but not so much that other artists have not portrayed the theme in a similar and metaphoric manner.

Frequently an artist will express emotions in a cruciform. Such an expression is referred to as a cross which omits the figure of Christ. Others include the figure. Thus, it would be called a crucifix. Sam Cady has devised the former, in an abstract form which resembles a figure but avoids all signs of pain and agony.

Cady's *Single Scull*, 2000, reveals an intimate body of mechanical features which can be appreciated for its complexity. Geometric shapes of various sizes join forces to request an intellectual inquiry of its contents. The artist seemed most concerned with a total and complete composition. *Single Scull* is an intellectual display but gives no hint as to its meaning in relation to the theme of the Crucifixion. With continuous study, one may discover the resemblance of facial features executed in a primitive but sophisticated manner. Cady has admitted that *Single Scull* is not an image of the traditional Crucifixion. If he were to re-title *Single Scull* and give it a religious name, one might discover an artist who is concerned with but unwilling to execute the image of the Crucifixion in traditional form. However, to include flesh and muscle in a physical body and blood flowing freely is not unusual. Several American artists have done so and success-

Single Scull by Sam Cady (2000). Oil on canvas. 96×48 in. Courtesy of the artist, Sam Cady. Photograph by David Plakke.

Golgotha by Martin Charlot (2001). Oil on canvas. 18 × 24 in. Courtesy of the artist, Martin Charlot. ©Martin Charlot 2001.

fully accomplished a satisfying composition. And such an inclusion is frequently rejected by a large portion of the viewing audience. Perhaps this explains Cady's conjectured reticence.

Martin Charlot

Although conceived as a Realistic portrayal, Martin Charlot's 2001 version of the crucifixion titled *Golgotha* slowly drifted into a meticulous Surreal portrayal. Instead of locating a skull before and beneath the cross as was customary among the European Renaissance painters, Charlot dramatically altered the order: he created a huge rock resembling a skull and positioned the three crucified victims upon it, with Christ retaining the central location. In the foreground, styl-

ized shapes represent the blood of Christ's body. The sophisticated arrangement of blood drops form the crown of thorns generally placed upon the brow. Charlot has used the entire canvas to convey his version. There is no empty or wasted space. In the uppermost segment of the background angels appear swooping down upon the event. Added to this is the significant symbol of the Resurrection apparent in the image of the Holy Spirit.

Charlot has used streaks of lightning to encase the three crucified forms which also serves to unify the composition. Tumbledown rocks on each side of the canvas recall turbulent earthquakes and childhood dreams of his birthplace. Palm trees are judiciously positioned to accent areas of the composition. Adobes, a garden, a child's wheelbarrow and a bull occupy appropriate sections of the foreground. The huge rock that dominates the central portion of the painting and which resembles a skull was suggested to the artist by a large rock which he saw in Israel.

Charlot's *Golgotha* is a fascinating approach to a tragic event. He has excluded all agony and suffering. Mourners do not exist, so the viewer approaches the scene carefully and slowly, recognizing the Crucifixion long after viewing other aspects of the painting.

Travis Throckmorton

Travis Throckmorton's 2001 portrayal *Pietà* combines all of the art elements essential to a masterful work. The color is humble and sacred, composition tight but intimate, and a oneness of focus and attention prevails. Particular body parts are distorted to add to the drama of the event. Hands are elongated and detailed to demand attention in the soothing process. In a visual sense the hands and heads of the two figures create an ultrasensitive composition. Mary's hands gently hold the body of Christ; her eyes do not gaze at Christ but are closed in profound prayer.

A delicate, all-over pattern occupies the entire background. However, it is dark enough to remain in the background and force the two figures to dominate the foreground. Because of the color relationship between foreground and background, the portrayal sustains a subjective atmosphere. Subtle halos surround the heads of Christ and Mary. Arteries and veins are evident in the major body parts of Christ, whose figure creates a haunting tone for the entire painting. The somewhat dominating feature of the foreground is Christ's loincloth, whose design is partially repeated in the headdress of Mary.

A bit of contradiction exists between the provocative facial gestures of death and sorrow and the refined treatment of the hands. *Pietà* presents an intimate moment in which no onlookers appear and no audience interrupts. One is forced to join in the contemplative mood and share in the artist's rendition of the death of Christ.

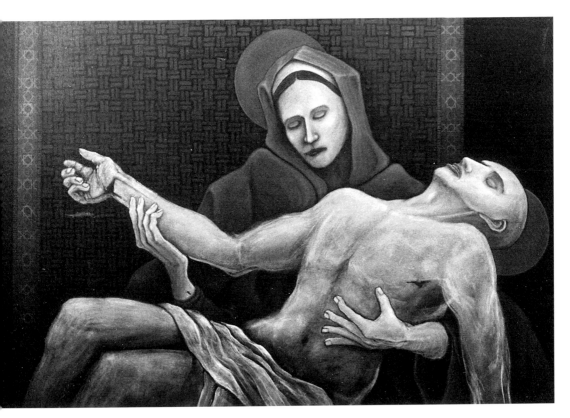

Pietà by Travis Throckmorton (2001). Acrylic on canvas. Courtesy of the artist, Travis Throckmorton.

In a detail of *Pietà* one sees a single aspect of two individual personalities. The artist has presented a close-up view of Christ's pierced side. The entire background consists of the chest wound of Christ.

At first glance one is tempted to view the painting as that of a single person—that of Christ. The rather subdued background contrasts perfectly with the contours of the female hand which tenderly clings to the body of Christ. The painting of the female hand appears surreal when contrasted with the downplay of the body of Christ. The relationship is an intimate one.

Focusing on the female hand draws attention away from the real and foremost aspect of the painting. The pierced wound is somewhat obscure and isolated before several views of the painting. In the detail of *Pietà* the elements of the wound and the hand take on an eerie atmosphere. There is no suffering. Death is present and the hand of Mary is comforting. There is a mystical nature to Throckmorton's paintings. The arm embraces the wounded body of Christ in an act of love and humility.

There are artists whose works appear dramatic regardless of the choice of media or subject matter. Throckmorton's religious works appear mysterious and provocative. Detail of *Pietà* is no exception and in spite of the content, it is a

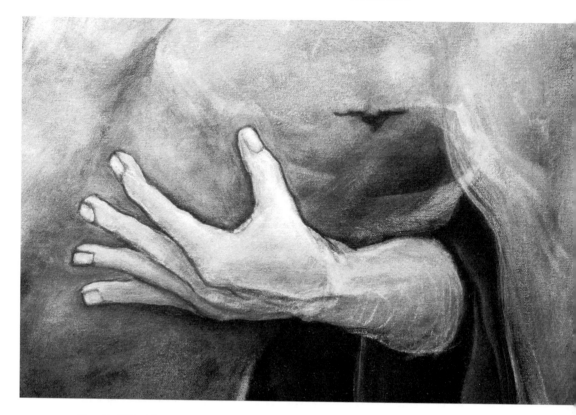

Detail of *Pietà* by Travis Throckmorton (2001). Oil on canvas. Courtesy of the artist, Travis Throckmorton.

pleasure to view because death is silent. His work is melodramatic, compositions are simple and the style is readily understandable. Throckmorton proves that Realism, by the degree of emotionalism experienced by the viewer, determines the direction an artist may take.

Jas W. Felter

Several artists have expressed the Crucifixion of Christ in social terms. In 2002, Jas Felter brought Christ into a contemporary social world with the addition of a popular object representing a commercial ad. The background of the digital image is rough, possibly a sidewalk or street. Standing out sharply against this neutral background with its interesting texture is a crumpled Camel cigarette pack. A shadow falls on the cigarette pack — the form of a man in the position of Christ crucified.

The vast background of "nothingness" is not without interest. The colors

Crucified by Jas W. Felter (2002). Digital image. Courtesy of the artist, Jas W. Felter.

Crucifixion I by Aileen Callahan (2002). Charcoal on paper. 20 × 15 in. Courtesy of the artist, Aileen Callahan.

are interestingly similar to the painted backgrounds of such earlier masters as Evergood and Tooker. The figure of Christ is seen in silhouette, revealing a set of strong shoulders, a trimmed down body and a pair of Primitive-appearing legs. The image of Christ is flat, thus avoiding the depiction of a three-dimensional individual. The upper section of the empty cigarette packet holds noteworthy images of highlights and shadows.

Felter has created somewhat of an optical illusion between the light cigarette package and darkened figure (Christ). Compositionally, visual perspective is nil. In fact, together all three elements (background, figure and object) create nothing more than a two-dimensional image. The baseline, middle ground line and the sky line all disappear to allow for the creation of a contemporary American icon.

Felter has avoided the ultimate display of a sharp contrast between the black figure of Christ and the total background. The textural nature of the background helps in retaining the close relationship between the two factions. Regardless of the approach used to define a major event or personality, art remains personal and Felter has used this freedom to allow for experimentation to attain satisfying results.

Aileen Callahan

In an Abstract Expressionist fashion, Aileen Callahan has produced the head of Christ and the full figure of a crucified form in a single expression on a single working surface. Since the idea was intuitively expressed one must search for the full figure which seemingly resides within the larger image of the head. The use of black charcoal defines both the figure and the head; the remaining lines form irregular geometric shapes. Few lines stand or float alone.

The title of this 2002 work, *Crucifixion I*, suggests that a series on this theme has been or is in the process of fulfillment. The series of rambling smears of charcoal constituting *Crucifixion I* appears to cover essential aspects of the head of

Christ as if to force the viewer to disregard the discovery of the crucified form. Vertical lines which appear to identify the crucified Christ are crossed with horizontal lines creating a temporary form of chaos. Nonetheless, there is much to be said for the uncovering of the temporary chaos and the eventual discovery that lies beyond.

The Abstract Expressionism of Callahan's work indeed makes it difficult to unravel her numerous lines so that an intuitive approach is not in vain. Because the application of knowledge is used in an intuitive manner, the expression generally evolves quickly and each brush stroke determines the next. This process continues until a satisfying result or a failure occurs. Errors are frequently made, forcing continued attempts to correct the errors which may in time succeed in the creation of an intuitive expression or a complete failure. Callahan's work is intriguing. It is simple, a focus in a single idea, and it is in a medium ideal for the technique being used.

Crucifixion II by Aileen Callahan (2002). Charcoal and wash on paper. 20 × 15 in. Courtesy of the artist, Aileen Callahan.

A second drawing by Aileen Callahan titled *Crucifixion II* presents a similar composition to that of *Crucifixion I*. However, although the approach is the same and the medium and composition are likewise the same, the Crucifixion appears to have given way to the Deposition. The head of Christ as witnessed in *Crucifixion I* has lost its original shape; that is, the cross appears to have collapsed.

Crucifixion II, dated 2002, is subjective since it occupies the majority of the working surface and the intuitive process all but eliminates details. There is no visual perspective. The entire expression is on the frontal plane. Abstract Expressionism invites various interpretations, but regardless of the extremely abstract approach, Callahan has produced what should be judged as an example of profound personal faith which remains unseen.

In both drawings the charcoal medium is utilized to its fullest. Washes have been added, when necessary. Line work has been executed with broad strokes and streaks of white paint added.

The cross seems to have completely diminished. At the top of the mass of struggling lines sits what appears to be a crown of thorns. There are figments of physical structure near the base of the painting, and as one scans this apparent chaos, the lower torso becomes evident. The white drops of pigment stemming

from the base of the crown of thorns are left open for interpretation; Callahan may know their meaning but, as in the Abstract Expressionist movement generally, some images are unaccountable. And so, one may analyze *Crucifixion II* as an intuitive outpouring of the artist's faith. Callahan's style of workmanship, after sustained study, reveals a strong structural composition.

Enrico Pinardi

Enrico Pinardi's crayon drawing *See No Evil* is dated 2002. It is a formally balanced portrayal of the Crucifixion. Ghost-like in appearance, Christ's physical features are not revealed. The face and head appear clothed in gauze. There is no physical make-up.

The two arms are stretched outwardly from the crossbar of the cross. Other than the circular head, the entire body is expressed in geometrically vertical or horizontal lines. The lower torso fades into the foreground which is similar to the background.

The white figure representing Christ is surrounded by a casual expression of black which gradually fades into the past. There is no sign of suffering. Rather, the image appears as a symbol of death. Thus, in Pinardi's work Christ has already died. The painting's simplicity is its strength. The opposing dark and light tones form a dynamic event, an event already passed. There can be no violence. Christ has died, but one may assume that joy is soon to follow.

Some viewers may object, not to the event, but to the manner in which the sacred event has been technically executed. However, withdraw the artist's purpose and manner of execution and the freedom of the artist is abolished. No one theme is appreciated by all. *See No Evil* reflects an ancient expression which is only occasionally still rendered today. The Crucifixion of Christ has been increasingly ignored in art for many decades. *See No Evil* is a reminder of Christians' celebration of victory over death.

Pinardi's *See No Evil* is a simple but unusual drawing, its figurative theme noteworthy. Much is said in a few words, so to speak. It is also a direction in which the artist of the 21st century may explore.

Crucifixion with Thorns, a 2002 drawing by Enrico Pinardi, is a dramatic display of death on the cross. Again, as in his *See No Evil*, the artist has avoided all anatomical features. There are no facial features except an awkward-looking mouth shaped like a peephole. Arms diminish beyond the shoulders and blend into the darkened background. The body is shaped like a casual rectangle. Christ's lower body is enmeshed in thorns, as if the thorns were growing outwardly from his body. Christ's headdress is a tripartite tam which covers his entire upper brow.

A dark cross is painted in the background behind the white figure of Christ.

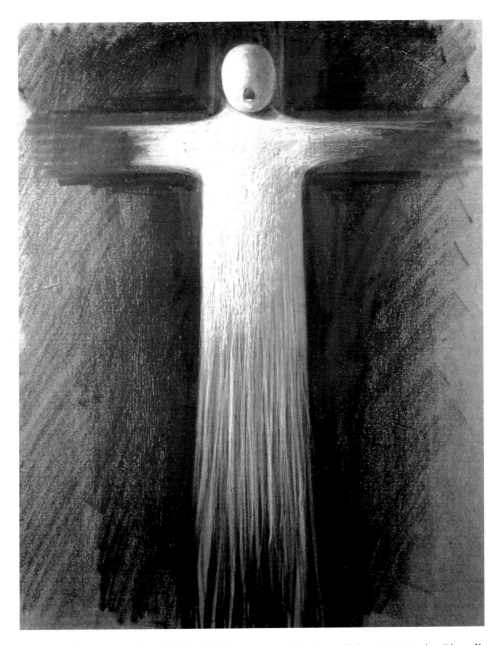

See No Evil by Enrico Pinardi (2002). Oil on canvas. Courtesy of the artist, Enrico Pinardi.

Essentially, *Crucifixion with Thorns* is comprised of three tones of a single color. There is a sense of the eeriness of Halloween, of the destructive as well as the notion of death.

Viewing the work as a formal composition, one is drawn to the single facial feature of the mouth. The interpenetration theory is applied as one plane overlaps another, and as each proceeds forward into the foreground. Thus, a three-

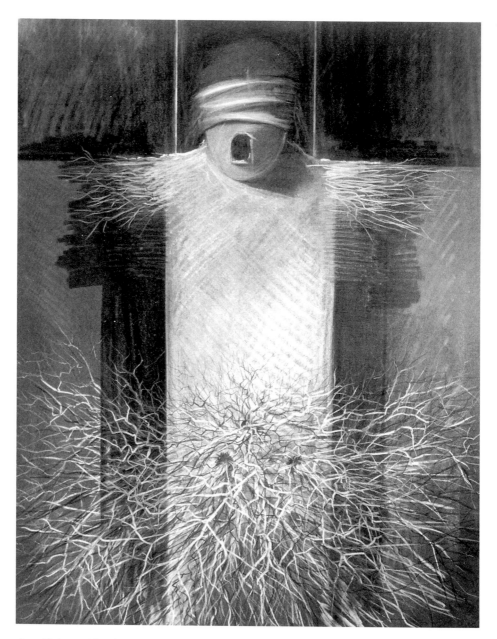

Crucifixion with Thorns by Enrico Pinardi (2002). Oil on canvas. Courtesy of the artist, Enrico Pinardi.

dimensional sense of movement occurs as one's vision moves back and forth, in and out of the background.

Crucifixion with Thorns is a subjective work because of the avoidance of any objects or figures that might possibly interfere. The viewer's response may create objective reactions rather than agreeable ones.

Enrico Pinardi spent 20 years as an ecclesiastical sculptor. His works may be seen in many large cathedrals across the country. In paintings like *See No Evil* and *Crucifixion with Thorns*, the sculptor's eye and hand are evident in the rich textures that characterize the works, even as his interest in the theme is obvious in the vividness with which he portrays it.

Concluding Remarks

It has become apparent that the theme of the Crucifixion of Christ was expressed as a parallel to memorable events during the history of America. The 18th century painters devoted their self-taught talents to the construction of shrines and outdoor chapels motivated by Catholic missionaries. Although the landscape dominated the American artistic expression, several artists of the period painted versions of the Crucifixion, and this was a direct influence of the European Renaissance. Benjamin West, Albert Pinkham Ryder and John Valentine Haidt were direct descendants of the European Renaissance. Other artists are credited with paintings of the theme, but such paintings were seldom shown to the public.

As the 19th century approached, the national outlook changed the growth of religious expression considerably. The traditional anatomical forms were evident. Symbolic images such as the halo were a mainstay. The number of artists expressing the theme of the Crucifixion increased, but their works were personal expressions and remained outside of public view.

The style stayed Realistic and continued so into the 20th century. Then, an intense growth of spiritual expression became evident. And yet, the church, which was the backbone of religious art in Europe, never totally accepted the styles of the 20th century artist in America. Instead, cheap copies of European masterpieces graced the interiors of American churches while original works were stored in church vaults. And in the case of many artists, their works remained in their studios because the artistic laity rejected any attempts for their public viewing.

The 20th century artist initiated what some critics called the Art of America. No more European influence. Now the Great Depression offered an abundance of ideas—starvation, suffering, droughts, the deaths of thousands of mortal beings. These tragedies became a parallel to the death of Christ on the cross. Following the Depression came World War II, and American artists were duly invited to paint its terrible scars. The deaths of millions of human beings in that

mammoth conflict became a strong motivation for some to paint the crucified Christ.

It was not until the end of the war that a new movement became popular. Abstract Expressionism, attributed to the drip methods of the artist Jackson Pollock, became a revenge or rebellion against the necessity of war. Since there was no definite theme governing the American artist, individual styles were introduced which accompanied Abstract Expressionism, and which were carried through the 20th century. Op Art, Pop Art, and Super-realism all competed for attention, but all three had rather brief lives.

Thus, the 21st century is a field of individual choice for the artist. Works have been introduced but are questionable as works of art. Several American artists have considered themselves unworthy to paint the crucified Christ and if they did succumb to the idea, the finished products have remained in the studios hidden from public view. It is unlikely that the church and the artist will blend their efforts until the church laity is educated and the church hierarchy accepts the talents of the serious religious painter. It takes a rare and awesome event to influence the spiritual attitude of the artist. The 2001 terrorist attacks upon America will undoubtedly motivate religious artists to re-create the death of the crucified Christ. The computer age may steer artists from the theme, but it will not deter the serious easel painter from expressing his or her personal reactions to the Crucifixion.

Because of the personal nature of art, there is no way of predicting the future style or movement that the artist may adopt. Art has become increasingly intimate, which has led to the dominance of it by Surrealism. Unless a major change occurs, the artists of the 21st century may succumb to a profoundly intimate expression which even they find difficult to comprehend, or they may resort to the traditional still-life or landscape. Not that these two themes are unimportant, but they lack the drama and intensity of a human tragedy.

Great art is that which is deeply personal yet shapes and is shaped by an entire nation. Until a major event occurs that effects the normal movement and action of people everywhere, the artist may continue to paint for the sake of art. Art would then no longer be a vocational necessity or a life's work, but a way to fill a gap, to consume time. The need to paint the Crucifixion must be a mutual agreement between the artist and the interested party, whether it be the church or the laity. However, it seems that the true expression of the Crucifixion is being sidelined or ignored and that the art world is becoming a mass medium.

BIBLIOGRAPHY

Books

Adama, Thomas. *Crucifix: A Message on Christ's Suffering.* New York: 1956.

Baur, John. *Revolution and Tradition in Modern American Art.* Cambridge: Harvard University Press, 1951.

Bowden, John. *Crucifixion in the American World and the Folly of the Message of the Cross.* Minneapolis: Augsburg, 1977.

Bruce, Marcus. *Henry Ossawa Tanner: A Spiritual Biography.* New York: Crossroad Publishing Company, 2002.

Cooper, Helen. *John Trumbull: The Hand and Spirit of a Painter.* New Haven, CT: Yale University Press, 1982.

Dillenberger, Jane, and Joshua Taylor. *The Hand and the Spirit: Religious Art in America, 1700–1900.* Berkeley, CA: University Art Museum, 1972.

DiPiero, W. S. *Out of Eden: Essays on Modern Art.* Berkeley: University of California Press, 1991.

Eliot, Alexander. *Three Hundred Years of American Painting.* New York: Random House, 1957.

Genauer, Emily. *Best of Art.* Garden City, New York: Doubleday, 1948.

Getlein, Frank, and Dorothy Getlein. *Christianity in Modern Art.* Milwaukee: The Bruce Publishing Company, 1961.

Grassi, Joseph. *The Five Wounds of Jesus and Personal Transformation.* New York: Alba House, 1989.

Groeschel, Benedict. *The Cross at Ground Zero: Our Sunday Visitation.* Huntington, 2001.

Grushkin, Alan. *Painting in U.S.A.* New York: Doubleday, 1946.

Henkes, Robert. *Crucifixion in American Painting.* New York: Gordon Press, 1980.

_____. *Insights in Art and Education.* New York: Irvington Publishers, 1978.

_____. *Notes on Art Appreciation: Some Go Unintended.* Kalamazoo, MI: Shelves and Slots, Nazareth College, 1979.

_____. *Prints Owned by the Library of Congress.* Washington, D.C.

_____. *The Spiritual Art of Abraham Rattner.* Lanham, MD: University Press of America, 1998.

_____. *Who's Who in American Art.* Farmington Hills, MI: Gale, 1990.

Hilderbran, Dietrich von. *Transformation in Christ.* Manchester, NH: Sophia Institute Press, 1948.

Hunter, James. *The Struggle to Define America.* New York: Basic Books, 1992.

Kane, John. *Six Lessons for Life.* Manchester, NH: Sophia Institute Press.

Kelly, Tony. *Beyond the Cross.* Liguori, MO: Liguori Publishers, 1998.

Khan, Ismith. *Crucifixion.* New York: Three Continents, 1987.

Kirstein, Lincoln. *Paul Cadmus.* New York: An Imago Imprint, 1984.

Kootz, Samuel. *New Frontiers in American Painting.* New York: Hastings House, 1943.

Labrie, Ross. *The Art of Thomas Merton.* Fort Worth: Texas Christian University Press, 1979.

Larkin, Oliver. *Art and Life in America.* New York: Holt, Rinehart and Winston, 1960.

Leen, Edward. *Why the Cross.* Princeton, NJ: Scepter Publishers, 2001.

Leepa, Allen. *Abraham Rattner.* New York: Harry Abrams, 1967.

Majozo, Estella. *Come Out of the Wilderness: Memoir of a Black Woman Artist.* New York: Feminist Press at the City University of New York, 1999.

McLeroy, Leigh, and Larry Dyke. *Revealing the Beauty.* Nashville: Boardsman & Holman Publishers, 1999.

Miller, Henry. *Remember to Remember.* New York: New Directions, 1947.

Moltmann, Jurgen. *Crucified God.* New York: Harper and Row, 1974.

Rhetts, Paul, and Barbe Awalt. *Our Saints Among Us: 400 Years of New Mexican Devotional Art.* Albuquerque, NM: LPD Press, 1997.

Romano, Umberto. *Great Men.* New York: Dial Press, 1980.

Romero, Mario. *Unabridged Christianity.* Santa Barbara, CA: Queenship Publishers.

Schonborn, Christof. *From Death to Life.* San Francisco: Ignatius Press, 1995.

Senior, Donald. *The Passion of Jesus Christ.* New Jersey: Catholic Book Publishers, 1997.

Sertillanges, A. G. *What Jesus Saw from the Cross.* Manchester, NH: Sophia Institute Press, 1996.

Steiner, Rudolph, and Peter H. Falk, eds. *Who Was Who in American Art.* Madison, CT: Sound View Press, 1985.

Walker, Paul, and Andy Lakey. *Art, Angels and Miracles.* Paducah, KY: Turner Publishing Company, 1996.

Weaver, Bertram. *His Cross in Your Heart.*

Wolfe, Gregory. *The Art of William Schickel.* South Bend: University of Notre Dame Press, 1997.

Wuthnow, Robert. *Creative Spirituality.* Berkeley: University of California Press, 2001.

Periodicals

Burrey, Suzanne. "Corcoran First Prize." *Art Digest*, March 15, 1953.

_____. "Rattner Portfolio." *Arts*, May 1957.

Coates, Robert. "American Taste. 100 Years at the Corcoran." *Life*, August 29, 1949.

Crane, Jane Watson. "Direction in Modern American Painting." *Studio*.

Crane, Jane Wilson. "Three Veterans at the American League. Rosenburg, Wilson, Weber-rattner." *Art Digest*.

Dame, Lawrence. "Boston Institute Surveys Art Digest." *Art Digest*, 1949.

Friedman, B.H. "The New Collector." *Art in America*, April 1945.

Getlein, Frank. "From Darkness to Light." *New Republic*, April 1958.

Grafly, Dorothy. "Painting in the United States." *American Artist*, December 1949.

Miller, Henry. "Mother and Child with a Comment by Rattner." Unidentified publication, January-March 1939.

Rice, Norman. "Rattner Portfolio." *Carnegie Magazine*, May 1957.

Sweeney, James. "New Directions in Gravure." Museum of Modern Art, August 1944.

Talmey, Allene. "Four Expressionists at the Whitney." *Arts*, February 1959.

_____. "Vogue Spotlight." *Vogue*, January 1939.

Vitrac, Riger. *Art News*, November 1957.

_____. "Vigorous Art in the Temple." *Architectural Forum*, May 1959.

Wolf, Ben. "Modern Religious Paintings." *Art Digest*, January 1946.

INDEX